PAINTING WITH ACRYLICS: From Start to Finish

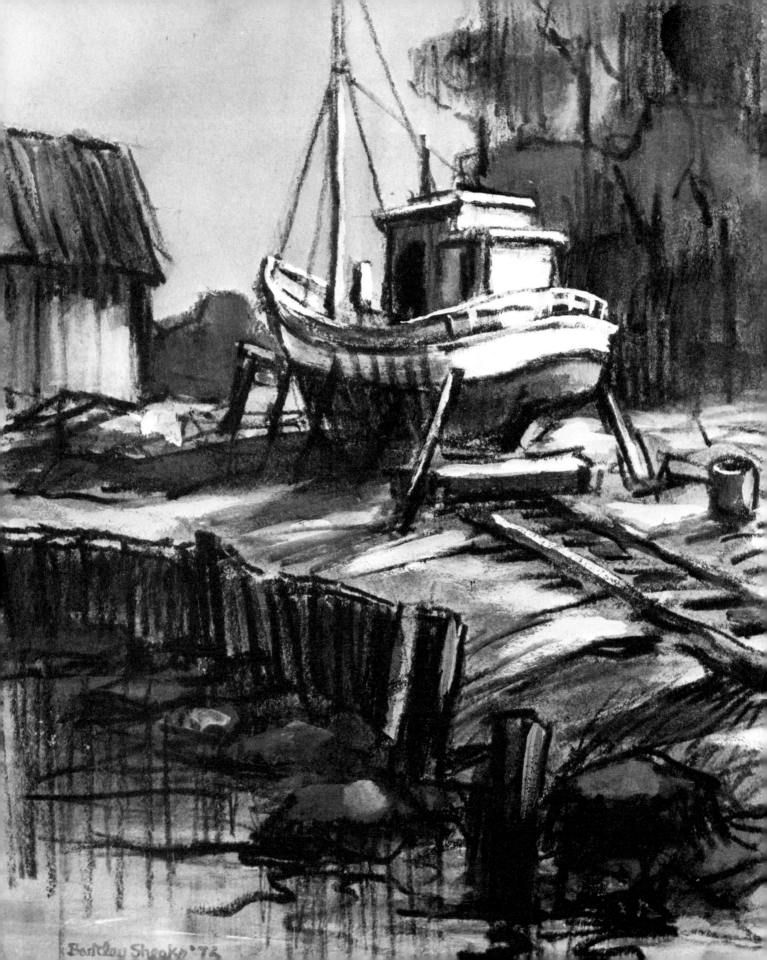

Bartlow Sheeks '72

PAINTING WITH ACRYLICS
From Start to Finish

Barclay Sheaks, *Associate Professor of Art,*
Virginia Wesleyan College

DAVIS PUBLICATIONS, INC.
Worcester, Massachusetts

About the Author

Barclay Sheaks is a graduate of Virginia Commonwealth University. His work is well represented in various public and private collections throughout the country including those of a score of museums—among them the Virginia Museum in Richmond, Virginia; The Butler Institute of American Art in Youngstown, Ohio; and the Columbia Museum in Columbia, South Carolina. He has had numerous one-man shows and his work has appeared in various commercial galleries, art centers, and museums across the United States. He has served as artist in residence for the humanities center at Richmond, Virginia, and as a traveling lecturer for the Virginia Museum.

His works have been exhibited at numerous museums, galleries, and art centers, including the Corcoran Gallery of Art in Washington, D.C., the Virginia Museum, the Norfolk Museum, the National Academy of Design, the Parthenon Museum, the Montgomery Museum, the Butler Institute of American Art, the Mariner's Museum, and the National Traveling Shows sponsored by the Smithsonian Institution. He currently has a one-man show of paintings traveling to leading museums, colleges, and art centers across the United States. He has won numerous prizes and awards in his field.

With over 20 years of teaching experience at all levels, he currently serves as Associate Professor of Art at Virginia Wesleyan College. A resident of the Lower Peninsula of Virginia for the past 20 years, he has a summer studio at Poquoson, Virginia, on Chesapeake Bay and a winter studio in Newport News, Virginia. Each year he spends some time lecturing and teaching seminars and workshops on art at various institutions, museums, and galleries.

Copyright © 1972
Davis Publications, Inc.
Worcester, Massachusetts, U.S.A.
All rights reserved.
Library of Congress Catalog Card Number: 71-186596
ISBN: 0-87192-048-4
Printing: Davis Press, Inc.
Type: Helvetica and Craw Modern,
 set by Machine Composition Company
Design: Jane Pitts

Front cover: Sunday Afternoon by the author.
 Line and acrylic polymer wash on Upson Board.
Back cover: Thickly applied acrylic polymer paint
 showing brush strokes.
Frontispiece: Chrismans Creek by the author.
 Line and acrylic wash on Upson Board panel.

Contents

TO EDNA

Acknowledgments

The first acknowledgment goes to Edna, my wife, whose endurance and patience is second to none, and who encourages and inspires me always.

I am particularly grateful for the valuable help from my friend Dr. Anderson Orr, who acted as the first reader, and to Janet Case, who did the typing. Others who deserve special mention are Bill Radcliffe and Mem Lemay for their outstanding photography; Ken Bowen, Allan Jones, and Russell Woody for their interest, assistance, and art work; and Bill Jennison, for the publisher, for his patient understanding.

Thanks should also be expressed to Sarita Rainey and George Horn for their helpful suggestions, and to Joe Baldwin and Art Astorino for their interest, and to the Hunt Manufacturing Company for its support.

I am most indebted to the numerous artists, teachers, and students who shared their experiences and ideas with me and contributed their art for this endeavor. I shall always be grateful for the many students who, over the years, have enriched my life and furnished the impetus for this book.

Contributing Artists and Students

Virginia Adams
Thelma Akers
Betty Anglin
Malcolm Anglin
Nancy Anglin
Laura Ball
Arthur Biehl
Kenneth Bowen
Gia Cacalano
Tony Cacalano
John Caddy
Edward G. Carson
George Chavatel
Michaelene Cox
Jean Craig
Patty Dawson
Jerry Ellis
Danny Fields
Jack Fretwell
William Gaines
Bruce Gordon
James Groody
Mary Anne Haines
Alice Hendrickson
Phyllis Houser
A. B. Jackson
Margaret Jett
Allan Jones
Cornelia Justice
James Kibry
Clarence E. Kincaid
Larry Knight
Vicky Koshell
John Matheson
Vicki Anne Mildner
Vance Mitchell
Robin Partin
Richard Porter
Gary Sea
Barclay Sheaks
Charles Sibley
Rene Smith
Nancy Sweet
Valfred Thelin
Frank Trozzo
Shirley Usinger
Theresa Williams
Leona Woody
Lurahana Woody
Russell Woody
Fae Zetlin

B.S.

Introduction

In the past few years, the systems and components represented by the words *polymer, acrylic,* and *acrylic polymer emulsion* have become vitally important in the world of the practicing artist, art teacher, and student. Acrylic polymer has gained popularity not only for its unique creative and innovative possibilities, but also for its easy adaptability to traditional techniques and practical uses.

This book should offer stimulation, encouragement, technical instruction, and approaches, both traditional and new, for using this medium. The author hopes, in showing credible examples of the use of acrylic polymer by established artists, teachers, and students, together with explanations and step-by-step instructions, that the reader may see how the medium can be used creatively to reach his goals.

The exercises suggested in the following pages are meant neither to suggest criteria for art nor to limit creativity. They are intended solely as technical drills to help in understanding the unique qualities of acrylic polymer. It is towards an improved understanding of this versatile medium that the book as a whole is directed.

Acrylic Polymer—What and Why?

For practical purposes and in order to avoid a lot of unnecessary technical terms, we may say that *acrylic polymer emulsion,* a by-product of petroleum-cracking processes, is a man-made product in the same general family with synthetics such as vinyl, fiberglass, nylon, and rayon.

The term *acrylic* means a certain kind of synthetic or plastic. In layman's terms it is like plexiglass, a durable, flexible plastic.

Polymer is a technical term that denotes a certain kind of molecular structure.

Emulsion is a certain kind of liquid mixture, in this instance water and acrylic.

As an artistic medium, then, we may generalize and say that acrylic polymer emulsion (which most users call simply "polymer" or "acrylic") is a plastic, water-based paint using acrylic as the binder to hold the paint pigments together and to make it adhere to whatever it is applied to. This acrylic in a polymer structure is in an aqueous mixture, more technically called an emulsion, giving us the term "acrylic polymer emulsion".

This medium, because of its water-base content, can be thinned with water and is soluble when wet or in use. It becomes resistant to water when dry. It may be applied in either thick or thin coats, with a brush or knife, loosely and freely, or with precision and fine detail in watercolor-like washes or in a heavy oil-like manner. When dry, it retains its flexibility. By its nature it is both a sealer and a preservative, giving it a wide range of possible working surfaces.

Historically and traditionally, painting media fell into various categories because each had its own characteristics and limitations and each more or less had to be used in certain ways to obtain permanency and the most expressiveness. Consequently, over the years different media became identified by their appearance and manner of use.

It is not hard to imagine how the superversatile media acrylic polymer caught the imagination of artists, educators, technicians, and paint manufacturers, not only because of its creative possibilities but also because of its practicality. Here was a substance that could be formulated with traditional and new pigments to produce a paint or system of expression that could easily and safely be used on most grounds and surfaces in all of the traditional techniques and even new ones. If the artist desired, he could combine washes, glazes, impasto, sculptured relief, and textural and collage-like additives in one product or piece of work. Unbelievable, yet here it was, with numerous scientific tests indicating that it should remain essentially the same, flexible and permanent, practically indefinitely, assuming the use of reasonable care in the creative process.

Preparing to Work in Acrylic Polymer

For convenience sake, each chapter or unit of this book contains its own basic supply list. In all cases these lists are kept to the bare essentials for an adequate experience in the techniques involved. In most cases the basic brushes and working tools are the same. For example, the list of equipment and materials for water color, in the first unit in this book, mentions most of the supplies needed for working in all areas. The artist who has the brushes and equipment for working in water color and oil will probably have everything necessary to achieve success. An attitude of open-minded enthusiasm and a desire to experiment are as essential as brushes and working surfaces.

About the Exercises
Suggested in this Book

While the exercises suggested in this book are important for building skill and for understanding the qualities of acrylic polymer, it is not necessary to make all of them into major productions. Many individuals become impatient with routine exercises. Keep up your interest by working rapidly and moving quickly from one assignment to another, changing and modifying exercises to suit your particular needs or situation.

A Space to Work

A small well-organized and efficient working space can be better than a large cluttered studio. It is necessary to have an area where one can work either flat, as on a table, or upright, as on an easel. A stand or table for holding paints, water containers, palettes, and mixing trays while you work is a must. Any area or corner of a room that is well-lighted and convenient to a sink or water supply makes an adequate studio.

The Acrylic Polymer System

Here are the mediums, modeling paste, gesso, and paints that you will need, with a brief explanation of their uses.

GLOSS MEDIUM. This liquid medium is used along with water as a thinner for the paints and as an additive to the paints when making transparent glazes. It also is used as a clear, shiny protective coating or varnish on finished works. It makes an excellent glue or adhesive. When mixed with the paints or used by itself, it dries with a shiny finish.

MATTE MEDIUM. Matte medium is similar to the gloss medium in its uses but dries with a nongloss matte finish.

GEL MEDIUM. This more viscous medium of gel has a paste-like consistency that dries with a glossy finish and may be mixed with the paints to act as an extender for working heavily. Thick, transparent, stained-glass effects can be achieved by using large amounts of this gel medium with the paints. It also makes an ideal adhesive for gluing large, heavy, and absorbent materials and is especially good in collage and construction-type sculpture.

MODELING PASTE. Used as a heavy extender for the paints, modeling paste also provides a textural- or sculptured-relief underbody to a painting. It can be modeled around an armature in order to produce sculpture in the round and can be used in various formulas for producing a durable acrylic papier mâché. Good for textural and sculptural frame decorations, it dries hard and may be cut and sanded when dry.

GESSO. A white acrylic paint, formulated primarily as a priming and sizing agent, it makes a brilliant white undercoat with a surface finish that is very similar to the traditional whiting, or plaster gesso. It can be tinted or colored with acrylic paints.

ACRYLIC POLYMER PAINTS. The paints are available in a wide range of colors packaged in jars and tubes. The tube paints, with their buttery consistency, serve best for general purposes.

Selecting the Minimum Necessary Colors

If you are inexperienced in selecting colors, do not be misled or confused by their various names. Open the tube or container so that you can see what the color really is. If when selecting colors other than black and white you are going to purchase only the minimum colors required, try to get the rich darker colors with lots of intensity or color power. They will go further and mix more combinations.

You will need: BLACK, WHITE, BROWN, BLUE, RED, YELLOW, and GREEN. Two additional useful colors are VIOLET and ORANGE. These nine colors will serve adequately in the beginning; others can be added as they are needed. It is best to get at least twice the amount of white as of other colors, since you will use much more of it.

PAINTING WITH ACRYLICS: From Start to Finish

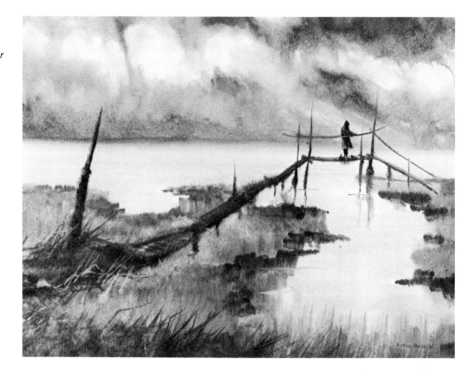

Widow's Walk *by author. Transparent use of acrylic polymer in a wet water color technique. Absorbent construction type paper was soaked with water before painting. The large blended areas were painted first while the paper was very wet; the smaller details last, so that they would not bleed as much. When dry, both sides of the painting were coated with a mixture of one half gloss medium and one half water to preserve the paper.*

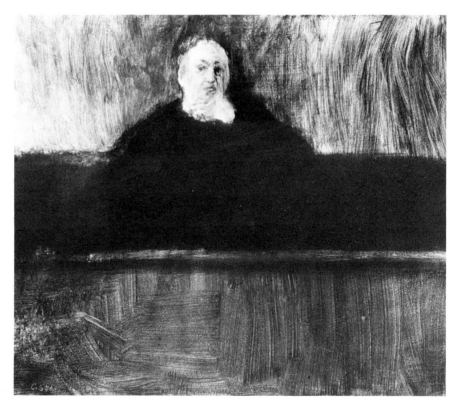

The Judge *by Charles Sibley. Acrylic polymer on paper. Thin applications of both transparent and opaque washes were combined on a paper working surface to produce this powerful study. Sibley works in a natural and very direct manner contrasting the qualities of transparent and opaque paint one against the other, using each to advantage.*

Acrylic Polymer As Water Color

For our purposes, we may define water color in the broadest, most inclusive way. Taking the word "water" as a guide, therefore, water color means a water-soluble paint used in a watery way. Pictures called water colors are painted with washes of color made of thin mixtures of water and paint. These paint mixtures may be transparent or opaque and may be used freely in a way that emphasizes their runniness, or in a restrained way that emphasizes line and detail.

With few exceptions, artists experienced in the use of traditional water colors find they can achieve or approximate any traditional method by using acrylic polymer.

Two important factors should be understood in the study of water color: the effect of the material used for the working surface, and the meaning of the terms "transparent" and "opaque" when describing the paints.

Historically and traditionally, the primary working surface used by water colorists has been paper. It has generally proved to be the one material most suited to the kind of paint application considered by artists to be characteristic of water color. Other materials accept water-color techniques, however, and each individual should experiment with those painting surfaces to find which are best for his uses.

In relation to water color, the term "transparent" means the ability to see through a wash or layer of paint. To lighten a particular color or tone, more water is mixed with the paint, making it thinner, more transparent, and paler because of the light surface on which it is painted.

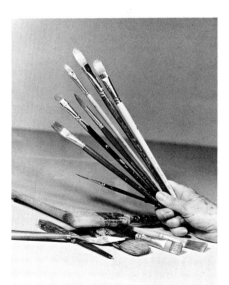

A practical assortment of brushes and palette knives for starting to paint with acrylic polymer.

Sky and Land *by Larry Knight, student at Virginia Wesleyan College. Acrylic polymer on mat board. The rich, tonal variations were achieved by applying thin washes of paint to a very wet working surface.*

The term "opaque" means just the opposite, the inability to see through. Opaque applications cover the painting surface beneath and block visibility. To produce a lighter color with opaque paints, mix white paint instead of more water with the color.

Opinions differ about the artistic judgment of mixing opaque and transparent paint in one picture. This book treats them both as water color and suggests experimentation, leaving the individual free to decide how he will use them.

The Wet Method

The wet method of water color may be described as the application of watery, runny washes of paint to a water-soaked surface, allowing, during this process, some or all of the washes to bleed or run together. Blending effects that are impossible by any other means can be achieved through this method. The possibilities of discovery through accident are numerous.

Necessary Equipment and Materials

The following list includes the basic minimum requirements of equipment and materials, except for the paints, paper, and working surfaces. With experience, the artist will add new brushes, tools, and materials as he recognizes the need for them.

1. One flat brush like that used by house painters, 2" or 3" wide, to be used for applying large areas of wash and for wetting areas.

2. One flat artist's brush, 1/2" to 1" wide, Number 8, 9, or 10, either stiff bristle made from nylon or pig's bristle, or a wash brush or sable, ox, or badger hair.

3. One flat artist's brush 3/8" to 1/2" wide, Number 5, 6, or 7, of the same variety as the preceding brush.

4. One round, pointed wash brush of sable or squirrel hair, Number 4, 5, or 6, to be used for fine lines and details. This brush should have the ability to come to a good point.

5. One palette knife.

6. One sponge for wetting, soaking, and absorbing.

7. One single-edge razor blade for scraping, scratching, and cutting.

8. Several containers to hold water for rinsing brushes and mixing the paints.

9. Wiping and absorbing materials: clean soft cloths, paper tissues, napkins, or towels.

10. One pencil for sketching.

11. One typing- or firm rubber eraser.

12. One sheet of medium-grade sandpaper.

13. Small amount of rubber cement or Maskoid.

14. One roll of 3/4" masking tape.

15. One-half cake of paraffin.

16. One white crayon.

17. Several mixing trays or palettes. Since water is used to thin the paints, a nonabsorbent waterproof material makes the best palette. A wide assortment of materials and objects may be used, including the commercially produced wooden, plastic, and metal artist's palettes; tear-off, treated-paper disposable palettes; T.V. dinner trays; and pieces of glass, plexiglass, and cardboard. Many artists use mat and cardboard scraps coated with shellac or acrylic paint or medium; some even use discarded dinner plates or platters (at least 12" to 14" in diameter is the smallest practical size, with larger sizes recommended unless more than one palette is to be used).

Materials for the Working Surface

Paper-type materials that absorb and hold water readily are most suitable for working with the wet method. All-purpose paper—a heavy, white sketch paper, as the name implies, used for pen and ink, pencil sketching, chalk, charcoal, and water color

Shell Forms *by Allan Jones. Transparent use of acrylic polymer on water-color paper. The paper was saturated with water before applying the acrylic polymer paints with a palette knife. The soft, blended quality is caused by the paints bleeding into the wet paper.*

—is good for these exercises, as is any medium or heavy-weight water-color paper.

Setting Up Your Equipment

Since this method can be messy, prepare your working area for the wetting, dripping, and splattering of paints and water.

Working flat seems the best arrangement for controlling the flow of washes. Arrange the palette, mixing trays, water containers, and working tools next to the area where you are going to place your painting while working. Have everything conveniently ordered so that you will not have to reach across the painting to pick up anything.

Cleaning Brushes and Equipment

All brushes and various painting tools should be kept moist while in use and cleaned with soap and water at the end of each working session. Dried paint may be removed by soaking the article in alcohol or lacquer-thinner until the paint has softened or dissolved and then washing it with soap and water.

Points to Consider
Before and While Working

1. The wetter or more watery the wash and the wetter the working surface, the more blending, running, and bleeding will take place.

2. Heavier papers will stand more scrubbing and scraping. They will stay moist longer and resist buckling and curling. Lighter papers, like drawing paper, newsprint, and construction paper, can give excellent results and special effects.

3. Colors can become dulled and muddied by mixing them with water that has become dirty from cleaning or brush-dipping. Change your water often or use several containers—one for cleaning the brushes and one for mixing with the paints.

4. Work rapidly. Set yourself a time limit between 20 and 45 minutes.

5. Keep your subject simple and select one that will lend itself to soft edges, blending, and running.

6. Trying to paint too much fine detail can be frustrating because it disappears and floats away on the wet surface.

7. Wet water color should be enjoyable. Don't worry about runs and bleeds you cannot completely control; the accidental might be more interesting than the intentional.

8. Do not try to learn everything on the first painting. Do a lot of paintings, make a lot of mistakes, and learn from them. When finished, evaluate your work against what you were trying to accomplish.

Preparing the Working Surface

In order for the wet method to function on any surface, that surface must be saturated with water. This can cause curling and buckling in some cases, especially if the surface is paper and relatively thin. Since paper is used most often for this method, procedures for keeping it smooth and flat should be considered. Saturating the surface is easily done by immersing it, holding it under a running spigot, or brushing or sponging both sides with water. All paper expands when it is soaked, and you should allow time for it to do so. While it is still wet, attach it to a board or frame with tacks, clips, or staples. Another effective method is to soak and expand the paper, then adhere it to a smooth waterproof surface, such as formica, tempered Masonite, or varnished wood, by firmly pressing the very wet paper onto this surface. The water acts as an adhesive and will usually keep the paper flat until dry. This method is the easiest to use until conditions require other measures.

Starting Exercises

The purpose of these first exercises is to introduce the individual in a natural way to the watery, blending quality of acrylic polymer used as wet water color. The main intent is to allow discovery by experimenting with runs and blends. For these first problems, limit your color choices to three or four, and use both transparent and opaque paint mixtures on medium-weight water-color paper or all-purpose paper cut into small pieces about 6″ × 8″ or 9″ × 12″.

1. Mix several ample juicy washes of different colors and apply them in dripping blobs to the wet paper. Observe how the colors bleed and spread on the wet surface.

2. Brush some thick paint on the wet surface, noticing the amount of bleeding that takes place compared to that in Problem 1.

3. Put several washes next to one another and then pick up the paper and tilt it at various angles, letting the washes run together.

4. Using a large brush, cover an entire surface with a wash of one color, and while it is wet, draw lines into it with several other colors, using a smaller brush.

Additional Ways of Starting

Having become acquainted with the basic characteristics of this method, try a few simple paintings using recognizable subjects. Select either transparent or opaque paint mixtures, or combine them and try a variety. Remember this is still the wet method.

1. Using several sheets of paper, do a series of paintings of skies, some stormy and moody, some clear, some with clouds, some without. This will test what you have learned about runs and bleeds. Work flat and with tilting. Place some simple forms that might be seen against a sky, in two of these pictures: for example, a hillside with a simple tree or a flatland with buildings. If these objects bleed excessively, wait until some of the moisture in the sky area has dried before painting them.

2. Select other subjects that you personally think would lend themselves to this method and do paintings of them.

3. Paint a very free abstraction, and while it is still wet, fold it in half, and press it together firmly. Unfold,

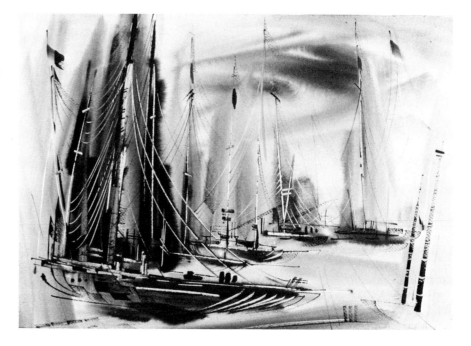

Ship and Sail *by Clarence E. Kincaid.
Transparent acrylic washes on water-color
paper. On a working surface which is
saturated with water, artist Kincaid applies
and manipulates the transparent washes with
a sponge. The dark lines were made by
applying ink with a stick, the light lines
achieved by scraping.*

see what subject it suggests to you, and emphasize this by drawing lines into it with a small brush.

4. Try a series using large single objects as the subjects, some with backgrounds, some without. Your subjects could include an interesting piece of driftwood, a sea shell, a human head—any object that you like or that interests you.

Lifting Techniques

Thus far our experience with the wet method has dealt only with applying the paint. The technique of removing paint can also be valuable.

Wet-method lifting is simply the selective removal of wet paint from the painting surface, using some tool or absorbent material.

Anything that will readily soak up the moist painted washes may be used. Absorbent paper towels, napkins, and tissues are excellent. Soft cloths and sponges, as well as brushes, are used frequently for this procedure. One reason many artists prefer the softer brushes of ox, badger, and sable hair for water-color painting is their thirsty absorbency, a quality more uncommon in stiff bristle brushes.

For lifting large areas where exacting control is not needed, crumpled absorbent cloths, paper tissues, towels, and sponges work best. For smaller areas requiring exact shaping and control, brushes can be used.

How to Lift

To lift large areas, simply press the selected absorber into the wet painted area. Once your sponge or tissue becomes full of paint, it no longer will lift. Be careful or you will be applying paint instead of lifting it. Sponges and cloths can be rinsed and used again. Some artists use paper tissues and towels because they absorb readily and can be discarded.

Brushes lift best when the bristles are moist. If the brush is dry, dip it in water until fully saturated, then damp dry by squeezing the water from the bristles, using the thumb and forefinger. To lift, dip or press the bristles into the wet, freshly painted area. When the brush becomes full, rinse, squeeze dry, and lift again. Keep the bristles clean or they will begin to apply paint. By shaping the bristles before lifting and by using the brush from various angles and

positions, more precise control can be achieved.

*Points to Consider
Before and While Lifting*

1. Lifting works best when the paint is lifted from a very wet area.

2. Results show most effectively when lifting is done from areas that are strong, bright, or dark rather than light or pale.

3. Try lifting from both transparent and opaque areas.

Ways of Starting

Continue to use the same paper and sizes suggested in previous wet-method experiments. Prepare the paper by soaking in the same way.

1. To develop a feeling of what lifting is, try several abstract exercises. Cover the working surface with a single bright juicy wash; then, using absorbers of different materials, experiment by lifting broad areas of various shapes. Try twisting and crumpling the absorbers in order to achieve a variety of lifted shapes. Lift both smooth areas and textured or mottled ones. The more you experiment, the more you will realize the advantages of this technique.

2. Lift from surfaces covered with washes of several different colors and tones: some bright, some subdued, others dark or light. As you work, notice how some colors and tones seem to lift more clearly and easily.

3. Create a variety of designs, using only brushes for lifting.

4. Combine all the ways of lifting into one abstract experimental picture.

5. Try the sky problems suggested before for the wet method, but this time create the clouds by lifting them instead of painting around them or painting them in.

6. Try a more complex assignment such as quickly lifting a simple landscape or cityscape from a dark background. Use tissue-type absorbers for large areas, such as clouds, large buildings, and trees, and your various brushes for smaller details, such as lines, smaller trees, limbs and trunks, and smaller buildings. Work rapidly or your picture will dry before you are finished.

7. Select several realistic picture assignments that seem to be fitting subjects for this technique.

Scraping As a Way of Lifting

At certain stages or degrees of wetness, interesting large areas and linear and detailed effects can be achieved by scraping the wet painted surface with flat-edged devices of plastic and metal, such as palette knives, plastic credit cards, and similar instruments. Use this method in a few simple experiments with several different background colors and tones to scrape into.

Combining
Wet-Method Techniques

One good way of approaching the combination of wet-method techniques is to try combining successful parts of pictures done in one technique with those in another.

Start trying new and more complex ideas for pictures, making them larger and using more colors. Always evaluate your results, however.

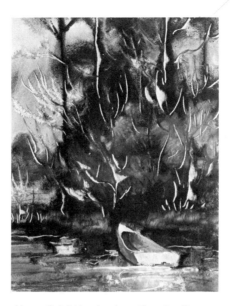

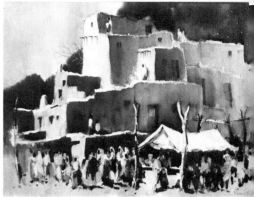

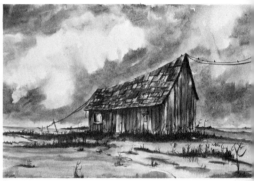

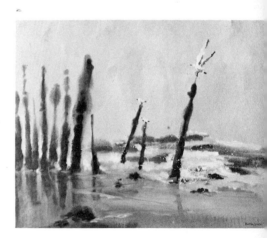

Above: Quiet Mooring *by author. Acrylic polymer on water-color paper. The light lines in the picture were created by scraping into the wet, painted areas. The light tonal areas on the sky and trees were lifted from dark washes by absorbing with paper towels.*

Right top: Pueblo Fiesta *by Charles E. Kincaid. Acrylic polymer on water-color paper. Using transparent washes to establish the large areas, artist Kincaid refines the light and dark pattern by introducing opaque washes.*

Fish Shack *by Larry Knight, student at Virginia Wesleyan College. This picture was painted directly on wet Upson Board, using both transparent and opaque acrylic polymer washes in wet-method techniques. The crisp lines were added with a wax crayon after the painting was dry.*

Right bottom: Surf and Gulls *by author. Acrylic polymer on Upson Board. Using the wet water color method of painting onto a surface saturated with water, the surf and gulls were painted with opaque paint, the rest of the picture with transparent washes. When dry it was coated with gloss medium and framed without glass.*

Experiments You Should Try Using the Wet Method

You should always experiment with various surfaces and materials while studying any technique. Try soaking wooden planks and pieces of plywood in water and painting on them, using the pattern of the wood grain as part of the picture. Construction papers, tissue, newsprint, rice papers, illustration board, tag and chipboard have their unique qualities and ways of bleeding, blending, and holding water. Using them, you might discover a material and technique that is meant for you. The building board, Upson Board, has an interesting quality when soaked in water. Fabrics such as canvas and unbleached muslin, as well as fabric-covered mat board of linen and silk, may also offer interesting results.

Questions Often Asked about the Wet Method

1. Can I draw my subject on the working surface before painting it?

There is no artistic law that prohibits a person from drawing or roughly sketching his idea before painting it. It could prove frustrating and restrict the chance of accidental discovery if the washes and bleeds run in a pattern entirely different from that of the drawing. Before painting in the wet method, many artists roughly sketch the general outlines of their subject or idea and use it as a basic guide. Try it for a while. Never rule out the value of just wetting your painting surface and painting directly into it.

2. What can I do if I don't like all that uncontrolled running and bleeding typical of the wet method?

Some softness and blending is characteristic of this particular technique. With practice comes the understanding of the variables, such as the amount of wetness of the paint and how much it will bleed. If you like sharpness and precision, perhaps another method, such as the dry or dry-brush, will be more to your liking.

3. Can one safely resoak a water color done in acrylic polymer after it has become dried?

One of the strong advantages of using acrylic polymer as a water color is that after it has dried or set it usually cannot be softened or dissolved with water. This means that you may rewet areas or soak the entire painting. The dried washes will not run or blend again, but new washes and runs can be painted into and over them.

4. Why do so many of my wet-method paintings, which were clear and bright while they were wet, appear dull and pale when dry?

The large amounts of water that must be used on the working surface and in the paints to create blending and running absorb the color pigments, dispersing and weakening them. Frequently they dry pale and dull. To compensate for this, mix your colors a little brighter and stronger than you wish them to remain.

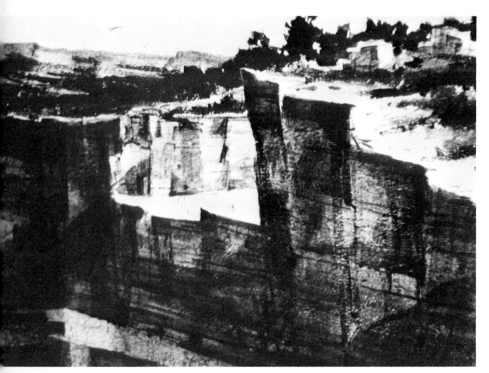

Quarry by Marc Moon. Acrylic polymer washes on water-color paper. Moon uses the dry method and the dry-brush technique to depict the crisp, textural contrast of stone and tree foliage.

The Dry Method

The dry method may be simply defined as the application of wet paint to a dry surface. Sharp edges, clearly defined forms, and frequent use of delicate detail are characteristic of this technique. Those who like to work carefully and slowly should find it satisfying. This technique is also generally easier to control for most beginners.

Necessary Equipment and Materials

The basic list of working equipment outlined for the wet method will suffice. You will not find as much use for the scrapers, and you will not need as many absorbent tissues and towels. To this list you should add a sheet of fine sandpaper, a firm typing eraser, and a single-edge razor blade.

Materials for the Working Surface

Paper-type surfaces are the most appropriate, popular, and versatile, although this technique can be used on surfaces of materials other than paper.

Preparing Your Working Surface

Sometimes curling and buckling is more problematic in this method than in the wet method because of the uneven amounts of moisture in the paint mixture applied to the working surface. This is especially true when working large on fairly thin paper, one reason why many artists prefer to use thicker types. Tacks, tape, and clips will hold the paper flat if curling arises.

Points to Consider
Before and While Working

1. Thin, watery washes can be applied more easily and will flow more readily than thick ones.
2. Transparent washes will show what is under them; opaque washes will cover what is under them.
3. This method allows for an unlimited working time since the drying time of all-over wetness is not an important factor.

4. Setting goals and objectives for evaluating your work is important.

Some Exercises for Starting

1. To help distinguish between transparent and opaque washes, use a dark color like black, Thalo blue, or Hooker green to paint two graduating tone scales—one with transparent washes, the other with opaque ones. Use one sheet of paper, placing the exercises side by side for comparison.
2. Try several quick abstract experiments with three or four colors working transparently. Strive for as much tonal variety as possible (light, medium, and dark). Then for the same problems, use the paints opaquely. To finish these drills with skill and awareness, try one combination of the transparent and the opaque. In these studies, to develop your skill in recognizing and creating varieties of light and dark, do not concentrate so much on the shapes and designs as you do on getting numerous different tones of light and dark.
3. Very quickly, do a few shape studies. Cover a sheet of paper with varieties of exact shapes, large, medium, and small, with both curved and angular outlines. Try to keep them neat and precise. This exercise increases awareness of appropriate brush selection and use. Create some white shapes by painting the background around them, using exposed paper as the shapes.
4. To get acquainted with another kind of blending, experiment with creating soft edges. This is easily done by brushing clean water into any moist, painted edge. The wet paint or wash will blend into the water, although sometimes a little helpful stroking is needed.

Deciding What to Paint

Personal choice is an important factor in selecting subjects for any kind of painting. Painting what gives you pleasure makes the work more interesting and enjoyable. Being original is important. Originality in this instance means your own idea, not a

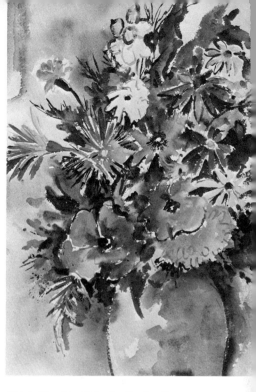

Above: Floral by Betty Anglin. Acrylic polymer used as dry method water color on water-color paper. A good example of painting directly on the working surface with transparent washes, without drawing or sketching the subject first.

Below: Floral by Nancy Anglin, age 11. Acrylic polymer used as dry method water color on mat board. Betty Anglin's daughter, in painting the same subject as her mother, sketches the subject first on the working surface and uses opaque washes in some of the flowers.

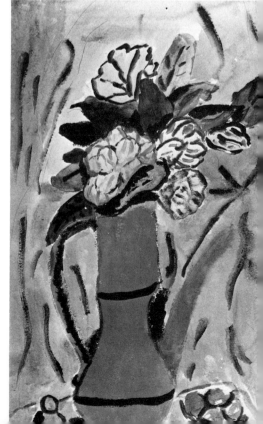

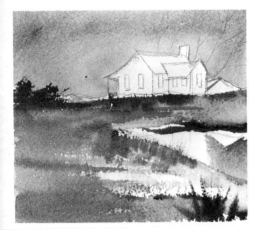

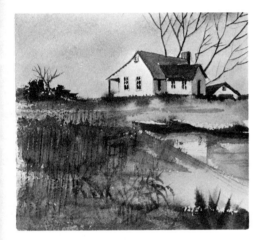

Above: The sketch by Ken Bowen on water-color paper illustrates the single-layer approach with transparent washes. The white working surface of the paper is left exposed to function as the white of the house and the reflection in the water. In the completed picture, only the trees and some of the grass have been painted over the original washes. Typical procedures in the single-layer approach, where essentially each area is finished with a minimum of layering or underpainting.

copy. Many artists paint an arrangement of objects in their studios. Some paint out-of-doors, on location, while others prefer merely to sketch outside, returning to the studio to complete the picture. There are those who have the gift of being able to make everything up. Most individuals new to the art of painting, however, find working from some direct source not only valuable but also necessary.

Opinions differ among artists and teachers about the advisability of painting from photographs and slides. Each individual has to be the final judge in this matter, but it is certainly worth considering or discussing with your teacher or fellow artists.

Whichever topic you select, your chance of success is greater if you keep your first pictures simple.

Two Ways of Approaching Your Subject

In order to simplify our thinking about picture-building, let us examine only two distinctly different approaches—the *single-layer method* and the *multiple-layer method.* By working within these methods, your chance of success will be greater, since you will understand what you are doing and why. After some experience with each, you will change and modify these approaches, and even combine them to suit your needs.

The Single-Layer Method

This method lends itself to working transparently, and for the most part

it would be efficient to restrict this method primarily to that kind of painting. Stated simply, the title describes the process. The picture is, more or less, painted one section at a time— each section separate and complete in itself. With the exception of small dark details, there is little or no underpainting. As an example, think of a picture of a white house on a hill against the sky, each item painted and completed separately. The sky is carefully painted around the house, and the hill is finished in one stage, putting in whatever details are needed. This method has many modifications, but for starting this basic concept is all that is necessary.

The Multiple-Layer Method

This method is most suitable for working opaquely because it utilizes both light and dark underpainting. In treating the same subject described in the single-layer method, the picture first would be divided into two basic areas without details, the sky and the hill. Both would be completely covered with basic colors. In this basic-color stage, the sky would first be painted under where the opaquely painted house would be eventually located. The details in the hill, such as roads, rocks, and bushes, would be painted on top of the first basic hill color after it was dry. The simple idea of painting one stage over another can stand much elaboration, but this concept is enough to start with.

Right: This sketch by Ken Bowen using transparent washes on water-color paper illustrates the first step or layer in the multiple-layer approach to painting. Here the picture is divided into simple areas and covered with color. In the completed multiple-layer picture, the house and other details are painted on top of the simplified, basic areas of color. Notice the similarity in the appearance of this finished picture to the finished picture done in the single-layer approach.

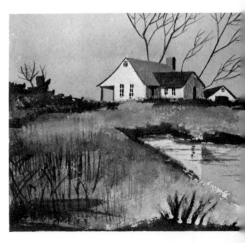

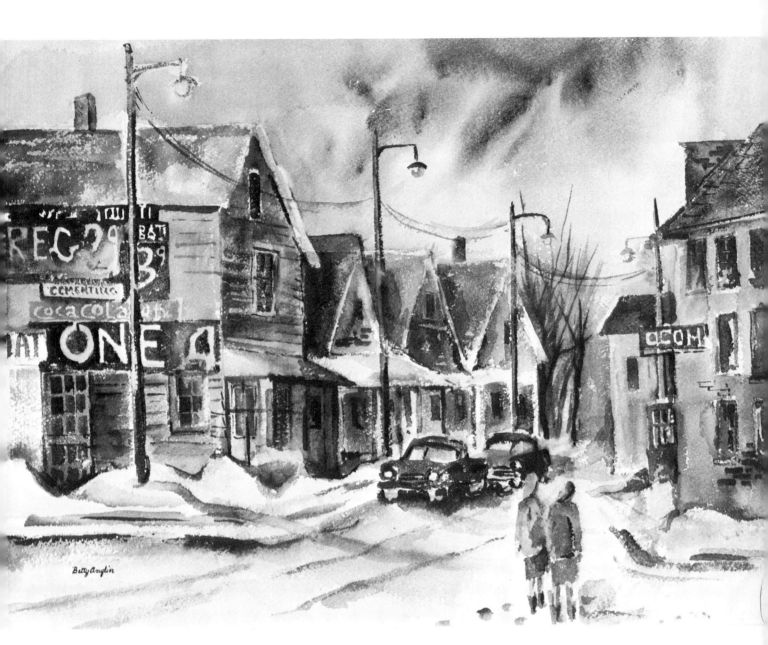

Winter Village *by Betty Anglin. Acrylic poly-
mer used as dry method water color. A good
example of the single-layer method using
transparent washes on water-color paper.*

*Starting with the
Single-Layer Method*

Select a subject that is not too complicated; remember that for this method you are going to think transparently. This means that you are going to paint around objects and leave the white of the paper showing for the light objects in your picture. Subjects could be landscapes with big open areas with a few trees or buildings or an arrangement of objects on a table, such as a basket and several pieces of fruit.

Making a small sketch of your idea with suggestions of the light and dark locations can prove helpful in organizing your thinking. This is a good way to solve the compositional problems before starting on the painting. Time spent thinking about light and dark contrast and in carefully spacing objects can aid greatly in creating a visually interesting painting.

Before starting, select the colors to be used and give thought to lights and darks. In what order will the sections of the picture be painted? Most often it goes more smoothly if the main or larger areas of the picture are painted first. Since this method will be mainly transparent, you must decide what areas are to be painted around, and if you have dark details to be painted last over lighter areas, such as trees against a light sky or dark bushes and weeds over a light field, locate the places where you are going to leave white spaces, such as highlights and reflections, clouds, etc.

If too much intellectualizing at this stage is frustrating, just start painting. Avoid working small. Select a piece of medium-weight water-color paper, no smaller than 12″ × 18″; 16″ × 20″ would be even better. Draw your picture on it, complete enough to give you confidence, and start painting.

Do set a general time limit for the completion of this painting, somewhere between an hour and an hour and a half. While you are working, remind yourself to keep moving along. If you run over your alloted time, it's all right, but the time limit keeps you moving and forces you into making decisions.

When you have finished, evaluate. Do another problem using this method or move along to the multiple-layer approach.

*Starting with the Multiple-Layer
Approach*

Consideration of subject matter and preliminary sketches to study tone and composition are also valuable for this approach to painting. Certain unique factors, however, should also receive attention. Since this is a layer-on-layer approach with overpainting possible in both light and dark, answer these questions before starting: What are the large space divisions and in what basic colors and tones will they be painted? Most details and small shapes will be painted on top of these large areas. Think in terms of painting over, not around, with the overall areas going down first, the small things on top of them.

Use the same size and kind of paper as in the single-layer method of painting. Sketch your subject on the working surface and commence painting. Set a time limit as before and do not forget to evaluate your work when finished.

*Experiments You Should Try
Using the Dry Method*

Use the multiple-layer approach for some of these experiments and the single-layer method for others.

1. Try quick studies on surfaces of different materials, such as newsprint, illustration board, and colored construction paper.

2. Coat a piece of cardboard or a heavy paper with acrylic gesso and do a dry-method study on this. Note while working how this surface takes the washes in a different way.

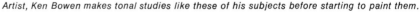

Artist, Ken Bowen makes tonal studies like these of his subjects before starting to paint them.

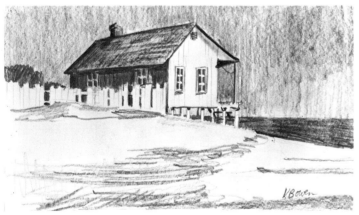

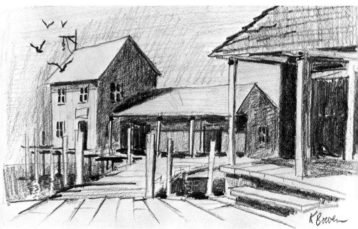

3. Take several of your finished dry-method pictures and experiment with them in these ways:

 a. Use the point of a single-edge razor blade for scratching in additional details and highlights. Grass details, foliage, textures, ripples and reflections on water, highlights on glass, and hair texture are a few subjects that lend themselves to this treatment.

 b. Lighten areas of your pictures that seem excessively dark or give interesting tonal variance to broad flat areas by rubbing with a firm eraser or sanding lightly with fine sandpaper. Soft highlights and hazy clouds are only a few of the things that can easily be achieved this way.

Experiments with Resists

 Resisting is the use of a technique to keep certain areas of the painting surface from being covered with paint. Many artists who wish to keep their work mainly transparent so as to utilize the white of the paper employ these resist methods. For example, if the picture should require a number of white seagulls in the sky, before painting they would cut seagull shapes from masking tape, press them down carefully in the desired positions, and then paint the sky over the taped forms. When dry, the tape would be peeled off, exposing the clean, fresh, white seagull shapes. The three most popular resist methods are as follows:

 1. Taping (which has just been described). When using this method, you must make sure that the edges of the tape are pressed down tightly, ensuring that no paint will bleed under them.

 2. Resisting or masking off with rubber cement. Those areas to be protected are covered with the cement before the painting is started. The paint is applied over and across the dried cement. When the painted area has dried, the cement is easily

Farm Scene *by Jerry Ellis, student at Warwick High School, Newport News, Virginia. A direct and uncomplicated example of the multiple-layer principle executed in a combination of opaque and transparent washes on all purpose paper.*

Taping, if properly executed, can be an effective way of masking off areas to prevent them from being painted.

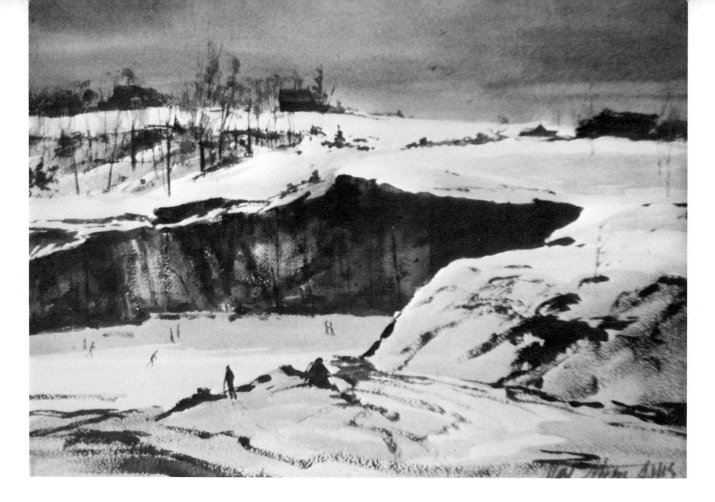

Winter Landscape *by Marc Moon. Acrylic polymer on water-color paper. The dry-brush technique of lightly dragging the paint across the working surface is effectively used in this picture in the trees, the rock cliff, and also in the shadowing of the snow in the foreground.*

rubbed or peeled off. There is a specially prepared, commercially produced product for this called Maskoid. It is applied with a brush, and the brush is cleaned with alcohol or lacquer thinner.

3. Wax Resist. In this method white paraffin is melted and painted on like the cement or Maskoid. The wax resists or rolls away the watery wash, if the paint is not too thick. In most cases, the wax is not removed. Drawing on the working surface with white or colored wax crayons and putting colored washes over them is a variation of wax resist. This method will be more fully described in Chapter 3. Practicing these resist techniques in actual projects will increase your water-color skill and understanding.

Questions Often Asked About the Dry Method

1. *How thick can your paints be while working with this method?*
An artist can do anything he chooses to do within the limitations of his media and materials. There is nothing wrong with using thick paint mixtures. The point is that when you do, your painting becomes another kind of painting, with a non-water-color appearance.

2. *Why is it that my small pictures nearly always turn out better than my larger ones?*
There may be a number of reasons. One cause for failure in large paintings is that while executing these paintings the artist frequently neglects to scale up his thinking and working along with the size of his painting. For example, larger brushes are almost always required. A 1/2"-brush may be adequate for applying paint to relatively large areas in a small painting, but a 1 1/2"- or 2"-brush is required for larger painting. Another frequent frustration encountered in scaling up the size of paintings is the failure to mix ample amounts of color.

The Dry-Brush Method

The third distinctly different way of using acrylic polymer as a water-color medium is the dry-brush method. When understood and put to practical application, this method gives paintings a variety of texture and imparts a richness of quality impossible with other methods.

The name itself almost explains its use. It is the technique of applying paint of low moisture content by lightly dragging or "scumbling" the brush across the painting surface. The results are intentionally textural. An infinite number of different marks and textures can be achieved by using different kinds of brushes and employing a variety of textural surfaces to paint on. This is a technique that may be applied to other kinds of painting as well as in water color.

Necessary Equipment and Materials

No major additions to your equipment are necessary for working in this method. After some experience, you may wish to purchase some additional brushes with bristles capable of producing certain textures. Have scrap paper or newspapers handy to use in removing excess paint from the brush.

Painting Surfaces for the Dry-Brush Method

As in other water-color methods, papers and cardboards serve best. Rough and pebbled surfaces make it easier to effect the textural quality so characteristic of dry-brush. Smooth surfaces allow the brushes to use their unique textural-making qualities. Since the dry-brush method leaves large areas of the working surface exposed, you should consider working on colored or tinted surfaces, such as mat board, construction paper, or tinted papers used for charcoal and colored chalks.

Points to Be Considered Before and While Working

1. The paint on the brush has to be partially dried or it will not give the necessary textures when applied. Excess moisture and paint may be removed from the loaded brush by pressing or dragging it across scrap paper until the desired condition and effects are achieved.

2. Deftness of touch is important while employing this method, since different pressures on the brush produce different textures and effects. Do not be discouraged if you don't produce the results you had in mind. Practice will help develop sensitivity of touch.

Selecting a Suitable Subject for Starting

Producing texture is the main characteristic of the dry-brush method. It is a natural way to depict foliage, fur, hair, wood, grain, rough stone, earth textures, etc. Let these facts guide your selection of subjects for your first exercises.

Getting to Know Your Brushes in a New Way for a New Technique

Stiff bristle brushes, especially the flat ones, can give the widest variety of textures. Their firm thick bristles will stand more vigorous use. The flat-shaped edge will cover an area evenly. They may be pressed into various positions and still return to their original shape, even after prolonged use for stippling—repeated punching or pushing the brush tip against the painting surface with a rhythmic or staccato motion.

The Soft Bristle Brushes

The sable-, squirrel-, ox-, and badger-hair brushes contribute to

Grass Study *by Allan Jones. Acrylic polymer on illustration board. Surprising clarity and crispness may be achieved using the dry-brush technique as illustrated in this skillful study rendered entirely in this manner.*

this technique. While they will not take the abuse and hard use of the stiff bristle, they are useful in other ways. The pointed brush bristles may be spread to create a variety of delicate strokes and lines or shaped to a thin point for soft, gentle, stippling strokes. The flat brushes may be used in a soft scrubbing manner to achieve a subtle, soft-edged blending.

Starting Exercises Using the Dry-Brush Method

1. Using small pieces of all-purpose 6″ x 9″ paper, test different brushes to see how many different ways you can use them. Do not try to paint a picture; just fill the paper with as many varieties of textural marks as you can. Drag brushes with the bristles in their natural position across the paper's surface for all-over tonal effects, then spread the bristles and strive for a sharp linear quality. Stipple some textures and even try taking your brush and slapping the bristles flatly against the paper. This slapping variation of stippling is frequently used for quick textural representations of foliage and other forms of vegetation.

2. Using one dark color, such as brown, blue, or black, paint a series of studies in which your objective is to recreate as realistically as possible textures seen in nature, such as grass, foliage, clouds, fur, hair, wood grain, and water ripples. These particular exercises need not result in complete pictures.

3. For this assignment, select several natural textures from the previous exercise and combine them into a complete picture. Select textures that do not look alike in order to give your composition visual contrast. Use a variety of color.

4. Select a noticeably textured, pebbled, or grainy working surface for these study exercises. Mat board, rough water-color paper, or material with a similar surface will do. On a single working surface draw a fairly large, interesting object with smooth, curved, and rounded contours. This can be sketched from memory or from the real object. Use your dry brush in a soft blending way to model or shadow, emphasizing the object's form. Do several of these. Your goal is to use the dry-brush technique to create soft textural shadows rather than sharp linear textures. The soft dragging or scrubbing technique, using soft flat brushes with small amounts of nearly dry paint on the bristles, is a good method for this. The subjects for these renderings could include fruit, gourds, seashells, stones, bottles, dishes, and similar objects.

5. For this problem, use black construction paper. If none is available, paint a piece of cardboard or paper black, using your acrylic polymer artist's paints. Select an object with light and dark contrast or with bright highlights, such as objects of glass, pewter, chromium, or silver. First draw them with pencil and then dry brush in the light areas and the shiny highlights, leaving the black as the darks or shadows.

Questions Often Asked About the Dry-Brush Method:

1. Do many artists paint complete paintings using this dry-brush technique?
A few perhaps, but not many. Most artists consider this a special technique, ideal for rendering texture but used mainly in combination with other methods.

2. How do I learn to control this technique more skillfully? I keep getting a blotchy, uneven quality, especially when trying to achieve an even, all-over tone.
Learning the correct brush pressure and knowing the right amount of dryness for the paint takes practice. One frequent cause of uneven blotches is an uneven or rippled working surface. When the brush drags across the raised hump, it leaves an extra amount or blotch of paint.

Study by Mary Anne Haines, student at Virginia Wesleyan College. Acrylic polymer on all-purpose paper. Both opaque and transparent washes are used in a dry-brush method of application.

The Dock *by Ken Bowen. Acrylic polymer on water-color paper. Using essentially a single-layer approach with transparent washes, artist Bowen combines water color methods and techniques. The sky is executed in the wet method with the dry method being employed throughout the rest of the picture. The resist technique of masking was used for the white gulls and pole structures against the sky. Scraping and scratching techniques were used to help depict the reflections in the water.*

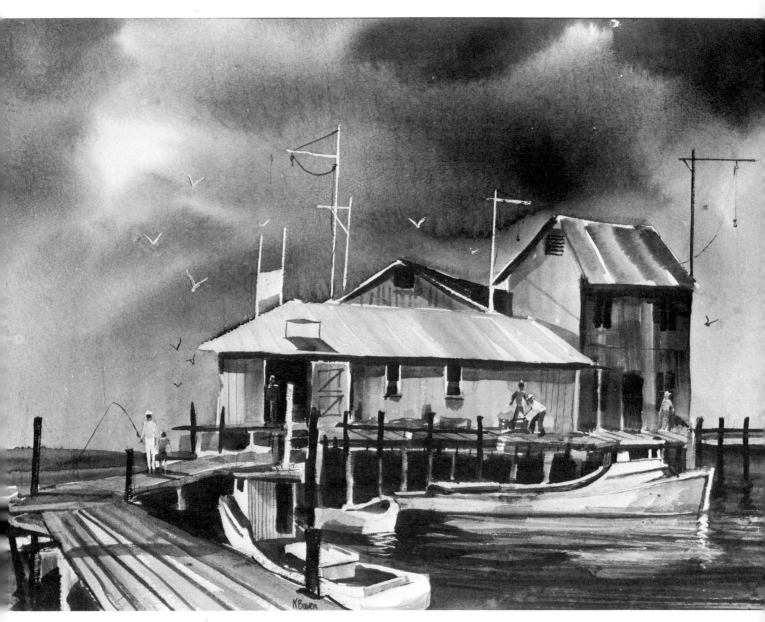

The Combination Method

By now you have become familiar with many of the basic working tools of painting and some of the qualities of acrylic polymer from the water-color experiences of the wet, dry, and dry-brush methods. Now you are ready to work successfully with the combination method, which is the combined use in one picture of the wet, dry, and dry-brush methods.

Necessary Equipment and Materials

If you have the necessary paints, materials, and painting tools for working with the other methods, you have the supplies needed for the combination method.

Materials for the Working Surface

Working surfaces for the combination method are the same papers and related materials used for the wet, dry, and dry-brush methods. Medium-weight water-color paper or heavy all-purpose paper is recommended for general use.

Organizing Your Thinking Before Starting

Learning to combine the various methods and their techniques is not so complicated as you might imagine, and there are numerous valid approaches. These approaches can be loosely divided into two categories: the intuitive or instinctive, and the logical. Each has its value, and the one you select as a way of entering into the combination method will depend upon your personality and individual preference. You should try both approaches. Most artists end up using a combination of both. These approaches and their underlying philosophies could be applied not only to water color, but also to other kinds of painting.

THE INTUITIVE APPROACH. The philosophy behind this approach is to capitalize on the knowledge gained from your prior experience with other techniques. You approach the painting of your picture by selecting your subject, sketching it first if you choose to. While painting, you trust your feelings and instincts, relying upon them to prompt your selection of which brush, method, and technique to use, and where and when it should be used.

THE LOGICAL APPROACH. This logical approach to the combination method starts first with a review of what you have learned about the wet, dry, and dry-brush methods, their uses and characteristics. Then after selecting the subject, plan a step-by-step procedure for action. Before making such a plan, you might ask yourself the following questions:

1. Is this painting going to be executed mainly transparently? If so, consider the single-layer approach and its basic procedures.

2. Is this painting going to be executed mainly opaquely? If so, consider the multiple-layer approach and its basic procedures.

3. How is the wet method going to be employed? There are basically two ways: wetting isolated and individual areas on the otherwise dry working surface before painting them, or soaking the entire working surface and roughing in all basic areas with color using the wet method, following with the dry and dry-brush method. The decision about which way to use the wet method could influence your choice of subject as well as your idea of how the finished painting should look. Both ways are worth trying.

4. How can the wet, dry, and dry-brush methods be used in their own expressive ways to the advantage of the whole composition?

Whatever you select as your subject, let it be a challenge. Choose something that will test your knowledge and skills, but remain within the realm of possibility. Familiar subjects make good subjects. In starting any new method or medium, using composition and subject matter with which you have had some success can give confidence. Adding a variation or another viewpoint keeps the picture from useless repetition.

The Plan of Action

Having considered logical questions and answers, you should organize your action in a simple orderly sequence, one that fits your style. The following example illustrates practical organization:

1. Select the subject matter.

2. Make prepainting study sketches if necessary.

3. Select a working surface and sketch the composition on it if the sketch is needed as a guide.

4. Prepare the working surface. Set up the equipment, paints, working tools, palettes, water buckets, etc., and have all needed supplies and materials ready for painting.

5. Decide on your approach, transparent single-layer or opaque multiple-layer.

6. Remind yourself of the order in which areas and forms are to be painted and which techniques you are going to use for those areas.

7. Set yourself a general time limit to keep the painting moving.

8. Make sure that your plan is loose enough to allow for discovery and change.

9. Begin work.

Following this Working Plan

Following a basic plan is one thing; letting it kill any chance of discovery and change is another. Most water colorists agree that spontaneity is the heart of water color and that capitalizing on the accidental is an important part of it.

Broadening Experiments You Should Try

1. Most artists working in water color confine their working surface almost entirely to traditional water-color papers and illustration boards. There are other surfaces that can be used, some of which you may have

Sandy Shore *by Emil Kashooty. Acrylic polymer on paper. Artist Kashooty used the intuitive approach in this painting. Working directly on the painting surface with little or no sketching guidelines, relying mainly on instinct and quick evaluations while working, this sensitive picture was produced by applying multiple layers of transparent washes.*

Landscape *by Marc Moon. Acrylic water color on water-color paper. Although fresh and spontaneous in appearance, artist Moon skillfully combines water color methods and techniques in this carefully planned logical approach painted with multiple layers of washes.*

Last Summer *by Valfred Thelin. Acrylic polymer on illustration board. This painting is the result of careful planning and skillfully executed technique, using transparent washes in a multiple-layer approach. The entire wood area was covered first with an ochre colored wash and the surface scratched with a wire brush, allowing the pigment to collect in the scratched areas. When dry, additional transparent washes were added to enrich the textural quality of the wood. Once dry, acrylic washes will not soften when worked over, allowing applications of additional washes to highlight and accent without fear of diluting or smearing underpainting, and background surfaces.*

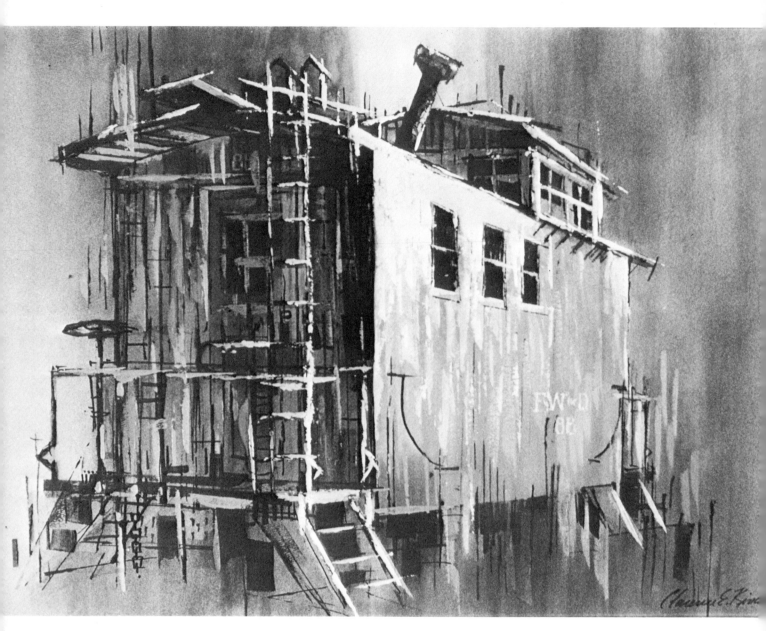

Retired 88 by Clarence E. Kincaid. Acrylic polymer on paper. Using transparent washes in the water color technique, artist Kincaid establishes the basic forms of the composition. Over top of this, he applies thick, opaque paint with a palette knife.

experimented with while trying the other water-color techniques. Try working both opaquely and transparently on various papers such as heavy construction paper, both white and colored, rice paper heavy enough to take the wetting, and various new synthetic papers made for water-color use, fiberglass paper, for example. Do small trial studies to see how these surfaces will react before launching out on a large scale.

2. If you have been sketching or drawing the picture on the working surface as a guide to your painting, try a complete painting without this aid. Organize the composition in your head and start painting. This exercise will keep you loose, free, and flexible.

3. For an interesting water-color experience with possibilities of surprisingly good results, completely soak a piece of chip or tag board in water and start painting while it is wet. Using your paints opaquely, rough in the big areas boldly and freely, allowing them to bleed. When dry enough, work over them with the multiple-layer approach, using the dry and dry-brush method for the smaller areas and details. Upson Board and mat board may also be used in this manner.

What to Do with Those Water Colors You Wish to Frame or Exhibit

Traditionally, water colors are matted and framed under glass, mainly because they were painted in thin washes on paper with easily damaged surfaces. Traditional varnishes could not be used for this protection because they darkened and yellowed both the paints and paper, destroying the fresh vital character of the painting. Glass thus offered the best protection from surface damage, dirt, and dust, but it was heavy and easily broken. Lighter plexiglass sheets were used by some artists, but they were expensive.

Entrance to Harwood *by Clarence E. Kincaid.*
Acrylic polymer on water-color paper.

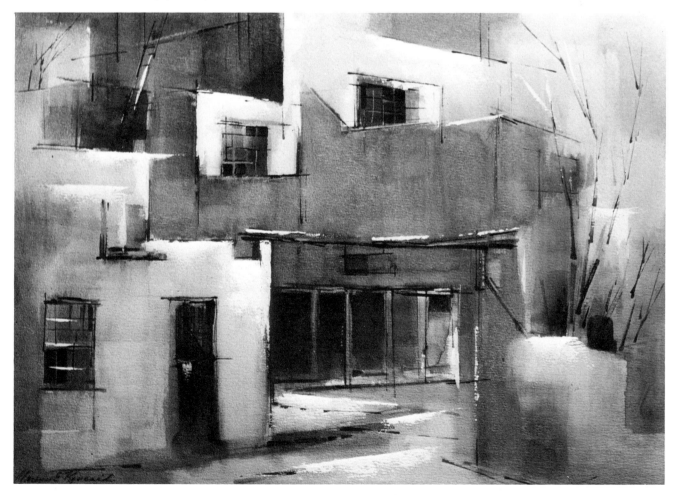

Today, instead of using glass to protect their water colors, many artists prefer to coat them with either the gloss or the matte medium which dries clear and causes little change in the appearance of the picture. When it is applied to the front and back of paintings executed on such impermanent materials as newsprint, construction paper, chip board, or tag board, it preserves them and can extend their life indefinitely.

By experimenting with these coatings on small paintings and your exercises, you may decide for yourself whether the results are pleasing and acceptable. If not, glass or plastic sheets will best protect your work.

When applying these coatings, remember that the gloss medium will dry with a shiny appearance, the matte with a nongloss, and that the two may be mixed for a semigloss finish.

For a thin mixture to penetrate and preserve absorbent surfaces, mix the mediums with one part water and one part medium. Several coats may be necessary to protect the surface. An inexpensive way to protect water colors for temporary display is to mat and back them with cardboard and then cover them with a sheet of thin pliable acetate.

Now that you have had some experience in painting with acrylic polymer and anticipate learning other techniques, you may benefit from the following suggestions:

1. Work hard and work a lot.

2. Enjoy your work; don't make it fretful or painful.

3. Don't believe every bit of advice that comes along.

4. Do not decide too hastily what is right or wrong in art, but do force yourself to make decisions based on your own knowledge and feeling about what is right and wrong in your own pictures.

5. Try not to affect a style of your own or take on any other artist's style. Work naturally and your style will develop naturally.

6. Keep an open mind and be willing to change your ideas about painting as you learn new things and develop new skills.

7. Try many experiments. This is one of the best ways of learning.

8. Always evaluate all of your work. This way both the successes and the failures become learning experiences. At its simplest, evaluation is asking: What did I do? What could I have done? What should I have done? What have I learned that can be carried over to the next picture?

Cardiogram of Sharp's Studio by Clarence E. Kincaid. Acrylic polymer on water-color paper. In this picture, the artist employed both transparent and opaque washes in a restrained manner to achieve a quality of simplicity and strong form.

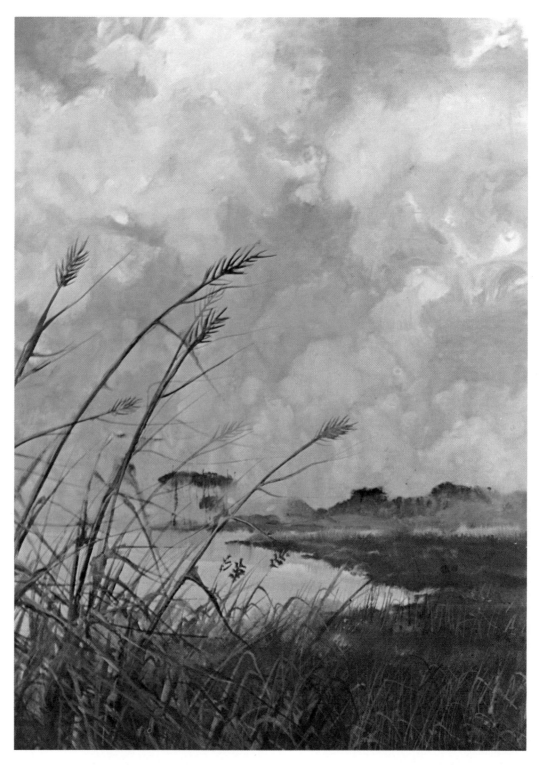

Broad Bay by author. Acrylic polymer on Upson Board. The soft, wet water color quality was achieved by saturating the working surface of the Upson Board with water, and then applying opaque and transparent acrylic polymer washes into this wet surface. When dry, the painting is sealed with protective coatings on both front and back and then framed without glass. Upson Board is a dense cardboard, building board available at most building supply outlets and lumberyards.

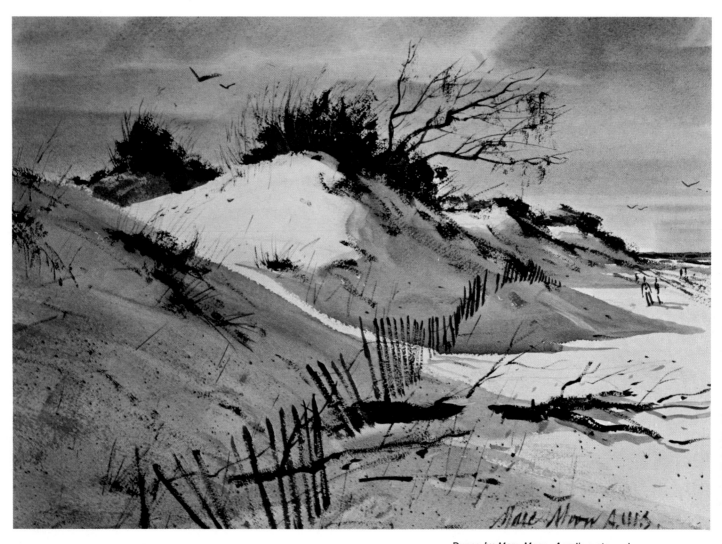

Dunes by Marc Moon. Acrylic water color on water-color paper. Artist Moon has devised a process which he called "Acrylic Water color." He uses traditional water color paints thinned with a mixture of water and acrylic polymer gloss medium. The medium causes the washes to set permanently and not lift or scrub up when dry. When the picture is finished, protective coatings of acrylic polymer gloss medium are brushed on front and back. It is then mounted on an Upson Board panel to give it a rigid support. It is framed without glass.

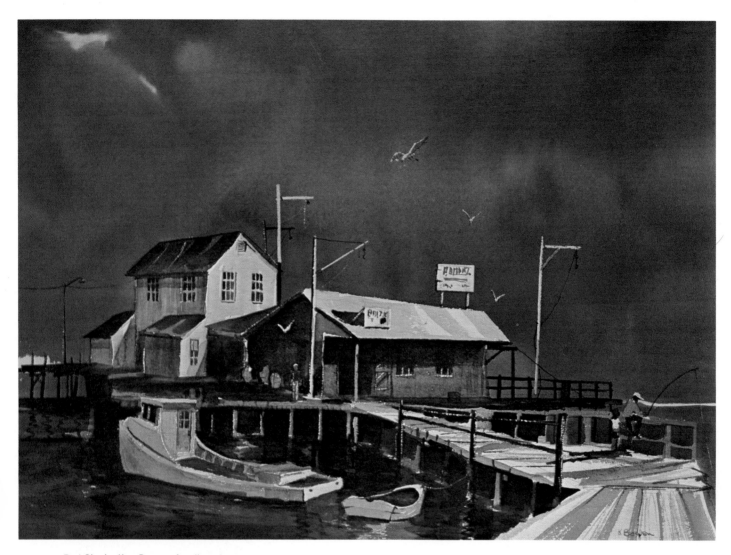

Red Sky by Ken Bowen. Acrylic polymer on water-color paper. The transparent washes of acrylic polymer paint, used entirely for this picture, give it unusual brilliance and clarity.

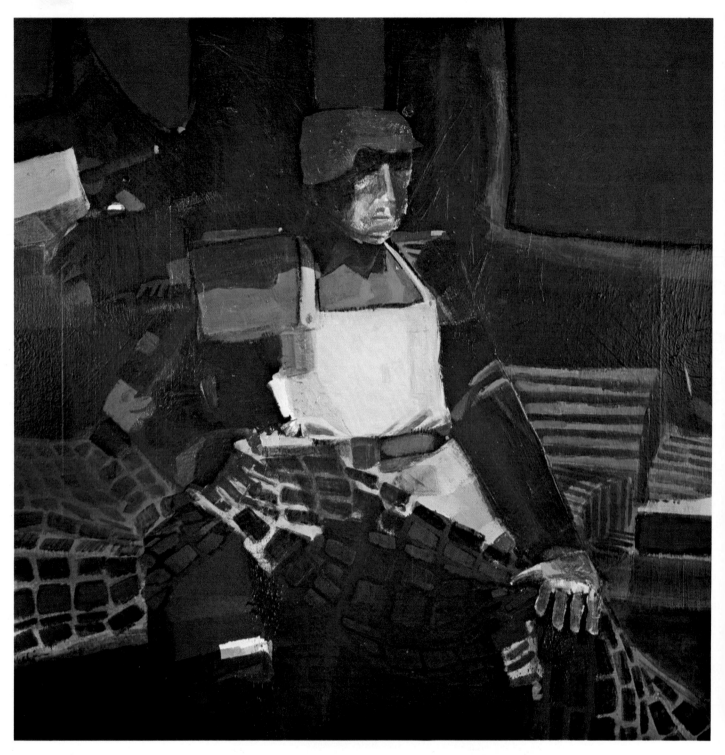

Above: Joel *by Valfred Thelin. Acrylic polymer on stretched canvas. Combinations of thick and thin paint applications including layers of transparent glazes give this painting unusual color depth.*

Right: Seed Corn *by Allan Jones. Acrylic polymer on Masonite. A skillful use of paint applied in the dry-brush technique, combined with sensitive draftsmanship produced this striking, realistic study.*

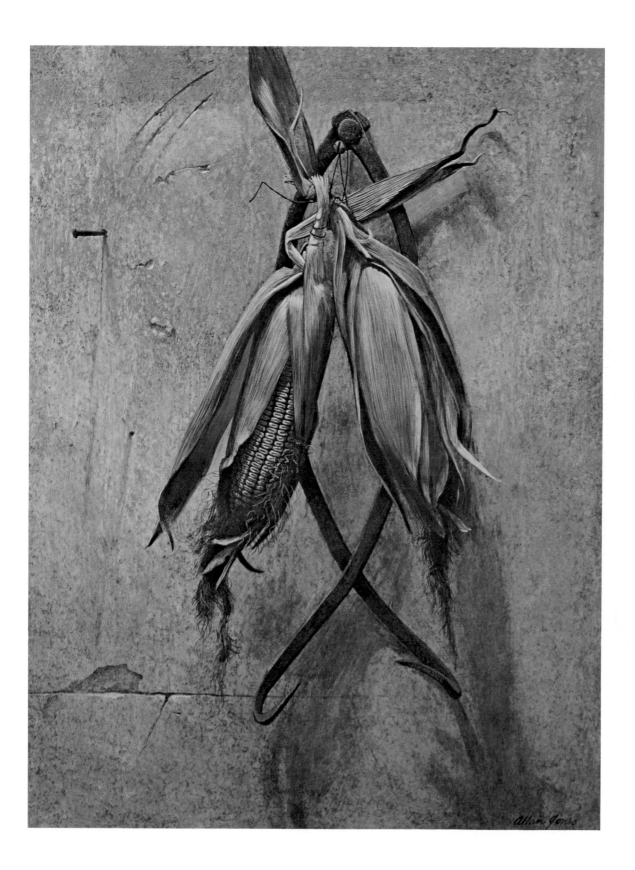

The Summer Watcher by author. Acrylic polymer on Masonite. The basic tones of this picture were formed of acrylic polymer glazes applied over a working surface of Masonite coated with acrylic gesso. This method of working enables the artist to achieve a luminous quality of inner light impossible to achieve with opaque applications of paint.

Adolescent Girl *by Russell Woody. Acrylic polymer on Masonite. To achieve the heavy impasto and textural quality in this painting, Woody mixed acrylic polymer modeling paste with the acrylic paints. Both brush and knife were used in the application. Glazes were added to finish the work after the thick underpainting had dried.*

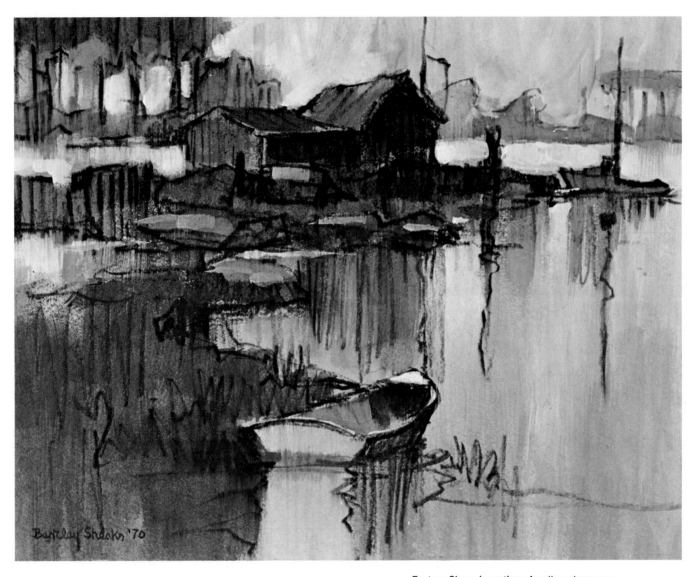

Eastern Shore *by author. Acrylic polymer on Upson Board. This line and paint combination was executed on an Upson Board panel coated with acrylic polymer gesso. The drawing was done with a lithograph crayon. Thin washes of acrylic polymer paints were applied over and through the drawing. Several coats of acrylic matte medium were applied to the finished painting for protection, enabling it to be framed without glass.*

Acrylic Polymer: Thick or Thin, Brush or Knife

Because of their versatility, acrylic polymer paints can duplicate or approximate the appearance and techniques of most traditional media. Nevertheless, certain unique qualities of this medium force us to devise special versions of traditional techniques. For example, acrylic polymers dry rapidly. This characteristic influences the techniques used in blending or graduating tones and colors into each other. These and other characteristics important in the application of this medium are dealt with in this chapter.

If you wish to start painting immediately, the following section on working surfaces may be scanned briefly before starting and referred to in depth as the situation requires.

Choosing Working Surfaces

When choosing working surfaces for acrylic polymer paints used in a non-water-color way, there are few limitations, since this medium will adhere to any non-oily surface that is not slick or shiny. Because it is self-sealing and acts as a preservative, there is no longer a technical need for sizing and priming. Many materials formerly considered nonpermanent may be used with confidence. The artist has new freedom in selecting surfaces for textural and paint-receiving qualities and can create his own by using acrylic gesso and modeling paste.

Freedom to use varied materials as a working surface for acrylic polymer paints does not assure the artist's satisfaction in the way a particular

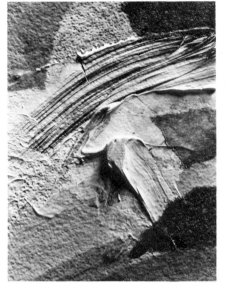
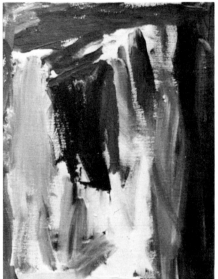

Left: Enlarged view of thickly applied acrylic polymer paint showing brush strokes.

Right: Shape *by* Leona Woody, age 3, daughter of artist, and author Russell Woody. Acrylic polymer on stretched canvas. Woody started his children painting with acrylic polymer paints at the age of two and states that they "are excellent as first media for children because they have a full range of possibilities at hand, from water color to heavy impasto, and they explore these immediately."

Below: Feeding the Gulls *by author. Acrylic polymer on Masonite. (Courtesy of the Seaside Gallery, Nags Head, North Carolina.)*

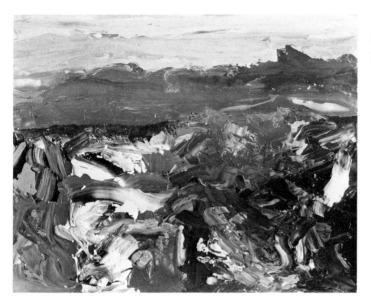

Abstraction *by John Matheson, Virginia Wesleyan College student. Acrylic polymer on Masonite panel. The paint is applied thickly using both brush and knife.*

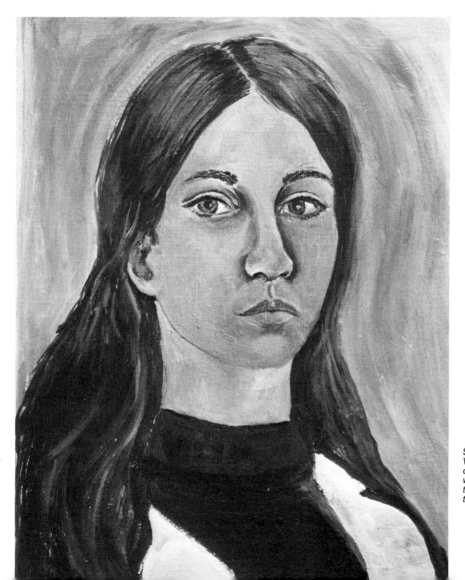

Self Portrait *by Margaret Jett, student at Virginia Wesleyan College. Acrylic polymer on canvas board. The texture of the canvas working surface shows through the many thin applications of paint, creating a textural unity in this sensitive portrait.*

Highway Sign *by Richard Porter. Acrylic polymer on stretched canvas.*

surface receives the paint. Often he may find the natural, untreated, unsized surface too absorbent or textural, so that applying the paint is difficult. Some materials like construction paper, chip board, Upson Board, mat board, natural wood, and many unsized fabrics fade and change color with age, altering the appearance of the picture if the paints have been used transparently or if parts of this natural surface have been left exposed. Coating with matte or gloss mediums will not prevent this. If the natural, untreated surface is not used because of its special qualities, little reason exists for its use. All surfaces should be experimented with and experienced in order to make suitable, pleasing, and purposeful selections.

Other factors to consider when selecting painting surfaces involve expense and availability. The considerations of the student trying to gain experience but save money may differ from those of the professional or experienced artist. The surfaces most widely used for general purposes are commercially prepared and stretched canvas or canvas boards and tempered and untempered hardboard panels, cut to size, sanded, and primed with acrylic gesso. Masonite, Upson Board, and hardboard are building and construction materials available at most lumber or building-supply outlets. Practical directions for cutting and preparing them are included in this section.

The generalized chart that follows includes a convenient reference and selection guide. It lists various painting surface materials according to their characteristics, with descriptions of natural surface quality, suggested use, preparation, and preservation.

Listing of Popular Working-Surface Materials and Their Characteristics

WORKING-SURFACE MATERIALS	UNTREATED SURFACE QUALITY	PREPARATION AND DURABILITY
Tempered Masonite and equivalent tempered hardboards	Frequently has a smooth and a textured side. Smooth side has a minimum absorbency. Textured side takes considerable amounts of paint or gesso to fill holes in texture.	Smooth side requires sanding before painting. May be painted on without priming. Rough side requires no sanding; ink trademarks must be removed by sanding, or they may bleed through the paint. Can be coated with either smooth or textured gesso coatings. Makes an ideal support for all general purposes. For heavy or relief applications, use rough side. Strong and hard enough to use in 1/8″ thickness in sizes up to 48″ × 48″. Very durable material.
Wooden planking and plywood	Wooden planking is generally very absorbent, but sometimes difficult to paint on if green and full of resin or sap. Air- or kiln-dried accepts paint best. Grainy plywood is absorbent. The grain in both of these wooden surfaces shows through thin paint applications, an advantage in some paintings.	Sand to remove grain and coat with acrylic gesso for a smooth surface. Use several coats if necessary, sanding between coats. All-purpose use. Wooden planking, unless pieced, can be used in widths up to 12″. Watch for warping in both planks and plywood. This can sometimes be prevented by priming both sides. Both materials are durable and long-lasting. Plywood may be used in single pieces without bracing in 1/4″ sizes up to 48″ × 48″, in 3/8″ and 1/2″ sizes up to 48″ × 60″. Thicker sizes are usually too heavy to be of practical use.
Upson Board, tag board, and chip board	These cardboards are very absorbent and quickly soak up paint and gesso applications. Surfaces range from smooth to lightly textured. May be saturated with a mixture of medium and water and painted on while wet with interesting blendings and water-color or fluid impasto effects.	Can be coated with gesso or medium for a general-purpose painting surface. Best not to use over 30″ in size unless backed by heavier material, except in the case of 3/16″ Upson Board, which may be used up to 48″ × 48″ without bracing. Not extremely durable unless impregnated with acrylic medium or coated with acrylic paint or gesso on all sides and edges to keep out air and moisture. Most economical in price. Not recommended for permanent use for heavy relief paintings. Subject to denting.
Untempered Masonite, or hardboard	Similar to Upson Board, but with a harder, less absorbent surface. Same general usage and paint applications.	Generally, same characteristics as Upson Board, only harder and denser, making it less subject to damage by denting.
Linen, canvas, cotton, duck, unbleached muslin, and similar fabrics	Extremely absorbent, soaking up paint very rapidly. Takes washes in a bleeding fashion almost like water-color paper. Can be soaked with water or medium and water mixed for interesting blending effects.	Can be primed with acrylic gesso for an ideal all-purpose working surface suitable for all paint applications except very heavy relief work. May be stretched over free-formed frames for shaped working surfaces. Very large, unpieced light-weight working surface possible. Very durable when coated with acrylic paint. Additional durability from sealing back with medium, medium mix, or acrylic gesso. May be glued to backing boards of Masonite or Upson Board, using acrylic gel or gesso as the adhesive, to make canvas-board painting panels. Easily subject to damage by puncture.
Commercially prepared traditional artists' canvas and canvas boards	See "Preparation and Durability" for linen canvas. Oil-primed canvas does not take acrylic paints as well as acrylic gesso-primed.	Same qualities as preceding, but already primed at the factory. Most American prepared canvas now primed with acrylic gesso.
Mat board, illustration board, poster board, and water-color paper	Moderately to extremely absorbent. Untreated, they respond best to water-color or wash techniques.	Can be primed with acrylic gesso to make general-purpose surfaces. Not recommended for relief work. Water-color paper and poster board require backing even in small sizes; mat and illustration boards, unless unusually thick, need backing if used over 18″ square. Should be sealed front and back with acrylic medium for durability. Subject to damage by tearing and puncturing.
All-purpose paper, newsprint, and construction paper	Very absorbent; best suited to water-color techniques.	Traditionally not very durable unless sealed with acrylic medium or gesso. Not recommended for general painting purposes. Protect from tearing and puncturing by framing under glass, or laminating to a durable backing board and coating finished surface with several coats of medium.

More About Working Surfaces

Very Smooth Surfaces

Smooth surfaces, such as sanded Masonite, or other materials with naturally smooth or sized surfaces permit the paint to create its own texture, or lack of it, and allow ease and freedom in the application and manipulation of paint. They are good for thin, even paint layers and the depiction of fine detail.

Light to Moderately Textured Surfaces

Light to moderately textured surfaces, such as sized and primed canvas and Upson Board, mat board, and Masonite (smooth side) that has been coated with moderately textured acrylic gesso, are general-purpose surfaces, suitable for most painting requirements. They are smooth enough for ease of paint handling, yet textural enough to support and hold heavy layers of paint. The slight texture will not interfere with thin applications and usual details and actually facilitates blending when using the dry-brush technique.

Some artists sand and then use the textured side of Masonite, but many find it objectionable because the hard, rough texture wears out brushes with amazing rapidity. Even when sized, it is difficult to paint on, except with a palette knife.

Heavily Textured Surfaces

Surfaces such as the rough side of Masonite; heavy, loosely woven fabrics; and rough and noticeably pebbled surfaces especially created with acrylic, gessos, and modeling paste are most frequently used for very heavy paint applications and for the support of low relief work and heavy collages. They are also used when the texture is intended as part of the picture. Applying paint to these surfaces is often difficult.

Creating a Special Working Surface —Priming, Sizing, and Grounds

In oil painting, the term *prime* or *size* has the same general meaning: "sealing off and coating the working surface." This necessary undercoating keeps the oil-base ground and the oil paints from bleeding into the wooden or canvas support, thereby deteriorating the material and destroying the strength of the paint, or "paint film" as it is called. The priming or sizing was usually a form of animal glue. Since acrylic polymer paints are both sealers and preservatives, they, unlike oil paint, do not need this priming. Priming a surface before painting in acrylic polymer is done primarily for these reasons: (1) to create a particular surface for a textural or technical need, such as sealing a too absorbent material, or creating a pleasurable surface for the artist to paint on and (2) to create a surface with a special color or tint for purposes such as adding luminosity for underpainting, glazing, or special effects.

Traditional gesso is like chalk or plaster and uses animal gelatin glue as its binder. It is usually inflexible and is basically intended for rigid supports or panels. Acrylic gesso is not a true gesso, but it approximates its appearance and surface qualities. Unlike true gesso, it is flexible and suitable for priming both rigid panels and flexible surface materials such as canvas, cardboard, and paper. It also acts as a sealer and preservative. It may be applied with a brush, roller, or palette knife and is ready to receive paint as soon as it is dry (usually 15 to 25 minutes). Acrylic gesso is a white, acrylic polymer emulsion paint that has a true gesso appearance and similar surface qualities (subject only to the limitations of an acrylic polymer paint). For most sizing purposes, many consider it superior to true gesso.

Acrylic-Gesso Application for Textural Surfaces

Using a rough-textured house-paint roller to apply gesso will give a prominently pebbled surface. A smooth roller gives a smooth surface. Many artists prefer to use an artist's brush or a house-painter's brush, since various kinds of brush strokes and stipplings result in a variety of surface textures. Sand and similar aggregates may be added to the gesso for special textures. For a supersmooth surface, use a smooth roller and sand afterwards with a fine sandpaper. Use the number of coats necessary to achieve the covering and surface quality required. Grain textures in natural wooden panels can be utilized by coating with a light layer of gesso thinned with a little water. When it dries, gesso seems to harden and emphasize the natural grain. Tempered and untempered hardboards may be scratched with heavy sandpaper and scored with tools—ice picks, nails, or awls for special linear and textural effects.

Cutting Hardboard and Other Panels

Although a few art-supply centers offer precut hardboard panels as a service to artists, in most instances artists secure the 4′ x 8′ sheets from local building suppliers and cut these themselves. All materials such as Upson Board or tempered and untempered Masonite may be cut with a regular carpenter's hand saw or power saws. Upson Board is easily cut by sawing or repeatedly scoring it with a utility knife. Masonite, even if tempered, may be cut in this manner, but it requires much more scoring with harder pressure on the knife and a sharp blade. For most purposes, 1/4″ Upson Board is the thickness to use. For Masonite, 1/8″ serves the general requirements.

Reasons for Presanding Hard, Smooth Surfaces

Hard, smooth surfaces, such as Masonite and other hardboards and particle board, need to be sanded for the simple reason that a hard, smooth, nonabsorbent surface does

Steps in the Park *by Arthur Biehl. Acrylic polymer on tempered Masonite. Working on a surface of sprayed, flat, white lacquer, Biehl works with very thin layers of paint to achieve subtle tonal blending and textural variation.*

not hold the paint well (the paint does not adhere well to it). Sanding creates minute scratches or grooves that give the paint something to hold on to. Even nonporous materials such as glass and metal will receive or "take" acrylic polymer paints if they are sufficiently scratched or sandblasted.

Use of Chip Board and Upson Board as a Painting Surface

The paint-absorbing quality of these materials makes them interesting for certain kinds of paint and wash application that may be preserved afterwards by coating with acrylic medium. While not strong, they are serviceable and economical. Unless they are backed with heavier materials, it is not advisable to work

larger than 30″ with any of them except Upson Board, which is thicker and stronger. To save money, many students coat chip board with acrylic gesso and use it for experimenting and for learning exercises. Usually both sides are coated with the gesso to prevent curling and warping. Prepared in this manner and cut into appropriate sizes, chip board makes a practical working surface for many of the studies and exercises suggested in this book.

Questions Often Asked About Working Surfaces

1. *Is it possible to put acrylic gesso over an oil painting and paint on top of it with acrylic polymer paints?*
As a rule, no. It is not a safe practice

because acrylic gesso, a form of acrylic polymer paint, contains water and will not adhere firmly to an oily surface. If the oil painting has been dry for 5 to 10 years, it might be possible to do this, depending on the thickness of the paint, but because of the oil in the oil paints, it would not be an ideal surface.

2. *How do you go about sanding Masonite and other hardboards?*
By hand or with a power sander. Use fine to medium-grade sandpaper and be sure that the entire surface is sanded. Sometimes the sanding dust obscures unsanded areas. The surface should be washed or wiped clean, inspected, and resanded if necessary. Unless heavy paint application is anticipated, the use of coarse sandpaper is not required.

Necessary Equipment and Materials

Those with experience in oil painting may use the same brushes and palette knives. Those who have not may use the same basic paints, equipment, and materials suggested for acrylic polymer as water color, providing enough stiff bristle brushes have been selected. Since part of this chapter will deal with the application of heavy, viscous paint, stiff bristle brushes will be necessary. Wash-type brushes with soft hair cannot properly manipulate paint of this thickness. Check your supplies to be sure that you have the following items:

1. One flat brush of the house-painting variety, 2″ or 3″ wide, to be used for washes, roughing in, and painting and varnishing large areas.

2. Two flat, stiff bristle brushes, either acrylic or oil-painting brushes, 1/2″ to 1″ wide, Number 8, 9 or 10, to be used for most general paint applications.

3. Two flat artist's brushes, 3/8″ to 1/2″ wide, of the same variety as the brushes listed above, to be used for the same general purposes.

4. One general-purpose painting knife, pointed and trowel-shaped for heavy, textural paint application and scraping.

5. One cup, dish, or container to hold the mixing medium for the paints. An empty, shallow pet-food can may be used for this.

Germination *by Virginia Adams. Acrylic polymer on stretched canvas. A good example of achieving a soft blended quality by using a combination of dry brush and wet-in-wet blending techniques.*

Derelict *by Allan Jones. Acrylic polymer on Masonite panel. Working on an acrylic gesso surface over a charcoal drawing, the artist uses washes of paint thinned with a mixture of gloss medium and water.*

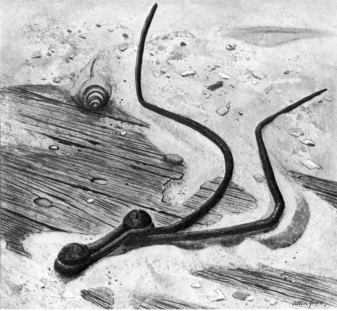

Piazza-Rain *by William Gaines. Acrylic polymer on stretched canvas. Using a loose and free handling of the paint in successive layers of varying thickness. Gaines achieves a shimmering and luminous effect.*

Mixing and Thinning Colors

The chapter on acrylic polymer used as a water color emphasized thinning with unlimited amounts of water. There was no danger of over-thinning or causing weak paint films or layers since the working surfaces were absorbent and the washes thin. Before entering into a study involving heavy, thin, and various layering applications, it is important to understand several technical facts about using paints in such combinations.

When painting in successive layers of the same thickness or in various combinations of thick and thin, the paints may be safely used directly from the tube, without mixing anything with them; they may be thinned with water to the consistency of thin cream and used in any combination of layering. Using extremely thin, watery washes in these combinations is not a good painting practice because too much water weakens the strength of the paint. These

washes will not hold securely to undercoats, nor will additional applications hold securely to them.

What to Mix with the Paints for Strong, Thin Washes

Thin the paints with a mixture of 1 part gloss medium and 1 part water. Any consistency is safe since the medium and water mixture gives additional adhesive strength. A container of this mix should be conveniently located near your palette.

Blending Techniques

Knowing how to blend in order to create soft edges and to achieve smooth graduated colors and tones is an important part of painting in almost any style or thickness of application. Because acrylic polymer paints dry rapidly, many artists experience difficulty with this. Three techniques for blending are the wet-in-wet, the wet-blend, and the dry-brush. With these three, most blending problems can be solved.

Working Surfaces for these Techniques

Since most of the exercises suggested for the blending techniques are technical learning experiences not intended to result in finished pictures, any smooth to moderately textured working surface that is not too absorbent will serve. Size is not important, although working small (9″ × 12″ to 16″ × 20″) is generally recommended. Commercially prepared stretched canvas or canvas boards are fine for these purposes. (A large canvas board may be cut into smaller panels with a utility knife prior to being used.) Small tempered or untempered Masonite or hardboards, panels of cardboard, Upson Board, or tag or chip board coated with acrylic gesso make efficient, economical surfaces for use in these exercises.

Blending with the Wet-in-Wet Technique

This is simply mixing and blending colors and tones directly on the painting surface. Any number of combinations is possible as long as those areas to be blended are wet enough. When the paint becomes too dry, another blending method must be used, or it can be painted over. Thin paint applications dry more rapidly than thick, heavy ones. Work rapidly and use large brushes with ample amounts of paint. Wetting large areas with the medium and water mix can facilitate blending and extend drying time.

Man Wearing Fez *by Robin Partin. Acrylic polymer on paper. A good example of wet-in-wet blending with free, loose brush manipulation.*

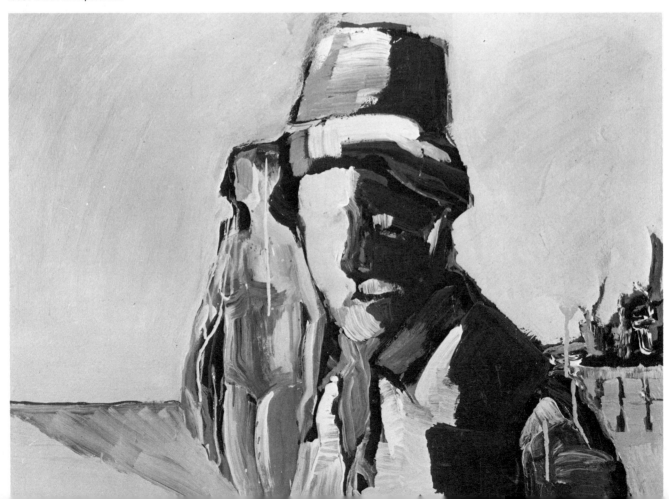

Suggested Exercises Using Wet-in-Wet Blending:

Unless otherwise stated, for those exercises requiring brushes, use as large a flat, stiff bristle brush as is practical.

1. Using a heavy paint application and interlocking brush strokes, blend a white area into a black area.

2. Repeat Exercise 1, but strive for a more even blending by using all horizontal strokes, working from top to bottom and dark to light.

3. Repeat Exercise 2, but use vertical strokes and work across the painting surface, blending from light to dark.

4. Repeat the first three exercises, but this time use thin paint mixtures.

5. Using moderately thick to thick paint and only 3 or 4 colors plus white, paint a small abstract picture with undefined blended shapes and forms. Use whatever size brushes are needed. Set a time limit of not over 30 minutes.

6. Proceed as in Exercise 5, only this time paint a simple realistic picture—a landscape, an object study, a floral subject, or a still life. Work fast and thick and utilize as much blending as possible.

Blending with the Wet-Blend Technique

The wet-blend technique is blending by diluting a wet area into a dry area with the water and medium mix. It utilizes the water-color blending quality of acrylic paints. Soft edges are achieved by stroking the medium mix along and into the fresh wet edge of the painted area. This is a useful method for modeling and shadowing small forms and details where soft, graduated tones are needed. Many artists employ this method in figure and portrait painting, using sable brushes. Always use the medium mix for this blending. If water alone is used for diluting it may cause a weak paint film.

Floral *by Patty Dawson, Virginia Beach High School student, Virginia. Acrylic polymer on cardboard. Thin applications of paint using both wet-in-wet and dry-brush blending techniques were employed to advantage for rendering the realistic forms in this picture.*

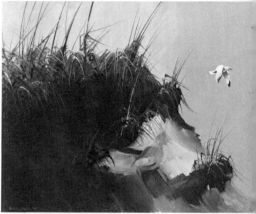

Dune and Gull *by author. Acrylic polymer on Upson Board panel. The wet-in-wet blending is facilitated by saturating the working surface with water.*

Abstraction *by Gia Cacalano, 5-year-old daughter of artist Tony Cacalano. Acrylic polymer on paper. Wet-in-wet and dry brush methods used in a natural and instinctive way.*

Across the Coffee Cup Watcher *by author. Acrylic polymer on Masonite panel. Thinned mixtures of paint were applied to an acrylic gesso surface using the wet-blend technique for achieving the soft blending, and graduation of tones.*

Across the Coffee for Two Watchers *by
author. Acrylic polymer on tempered
Masonite. Working on an acrylic gesso
primed surface, the artist achieved the grad-
uated tones by using the wet-blend technique.*

*Suggested Exercises for the
Wet-Blend Technique*

Try these exercises with both thin and thick paint applications.

1. On a white working surface, use a flat, stiff bristle brush, Number 10 or 12, and a bright or dark paint to make several separate curved and straight brush strokes. While they are still wet, soften one edge or side of each by blending with the medium mix.

2. Paint an area about 8″ square with a dark color and let it dry completely. Then, using white or a very light color, repeat Exercise 1 on this dark area.

3. To familiarize yourself with practical uses of this method of blending, do several simple paintings of subjects in which blended edges can be used to advantage. They may be object studies, landscapes, seascapes, floral scenes, or still-life arrangements.

Farm Scene *by Danny Fields, student at Menchville High School, Newport News, Virginia. Acrylic polymer on hardboard panel. Working almost exclusively with the dry-brush technique, student Fields shows the textural possibilities of this method.*

Blending With the Dry-Brush Technique

This is the same brush-dragging technique used in other media and described fully in Chapter 1. The blending and soft-edge effect are created by dragging the paint in a textural way across the dry painting surface. This method can be used effectively with both thick and thin paint application.

Suggested Exercises for the Dry-Brush Technique

1. On both smooth and textured painting surfaces, practice blending dark shapes and brush strokes into light backgrounds, and light shapes and brush strokes into dark backgrounds. Use a variety of paint thicknesses to become further acquainted with the handling qualities of acrylic polymer paint in various applications.

2. Using a familiar subject, paint a complete picture utilizing the dry-brush blending technique as much as possible.

Waiting for Spring *by Arthur Biehl. Acrylic polymer on tempered Masonite panel. This stark realistic depiction of natural textures employs the dry-brush technique to advantage.*

Winter Field *by John Caddy, Virginia Beach High School student, Virginia. Acrylic polymer on Masonite panel. Using the textured side of the Masonite as the working surface, student Caddy achieves unusual richness through the dry-brush application of many small brush strokes.*

Figure Resting *by Patty Dawson, Virginia
Beach High School student, Virginia. Acrylic
polymer on hardboard panel. A tapestry effect
is achieved by painting with small stippled
brush strokes directly on the unprimed
working surface.*

Potted Plants *by Betty Anglin. Acrylic poly-*
mer on cardboard. Thick paint applied with
stiff bristle brushes gives a richness to this
picture. The veins in the leaves of the plant
in the foreground were achieved by scraping
with the tip of a palette knife while the paint
was still wet.

Acrylic Polymer in Thick Applications

When used in thick applications, acrylic polymer has the advantage of easy manipulation, which combined with the rapid drying time allows for quick overpainting in any number or combination of layers with assured permanency. Many artists like the richness and textural advantages of working thickly or *impasto,* as it is traditionally called, and some of them work this way exclusively. For the first time in history, the artist now has a medium in which he can work as thickly as he chooses with little chance of cracking or sloughing off. This enables him to concentrate fully on expressing himself.

Brushes and Knives for Applying Paint in Thick Applications

Flat, stiff brushes of either synthetic or pig bristles are best for thick paint application. Because of their firmness, they can pick up heavy paint and apply it easily, unlike soft-haired bristles that bend and become entangled in the paint.

Painting knives come in many shapes and sizes. The trowel-shaped ones with long tapering blades of fairly springy temper are the most versatile. However, small pointed ones are useful for achieving small detail. The traditional spatula or long-bladed knife used for mixing paints may also be used to apply paint.

Brush or Knife—Which to Use?

For painting thickly, both the brush and the knife have special uses. Experimenting with each will aid in making the appropriate selection for your work.

The flat, stiff bristle brushes can lay on the heavy paint in a variety of stroking and textural ways, pushing and dragging it around or piling and layering it. But for compressing and sculpturing the paint, the knife with its springy blade is ideal. It can also be used to scrape, dig, texture, and remove paint.

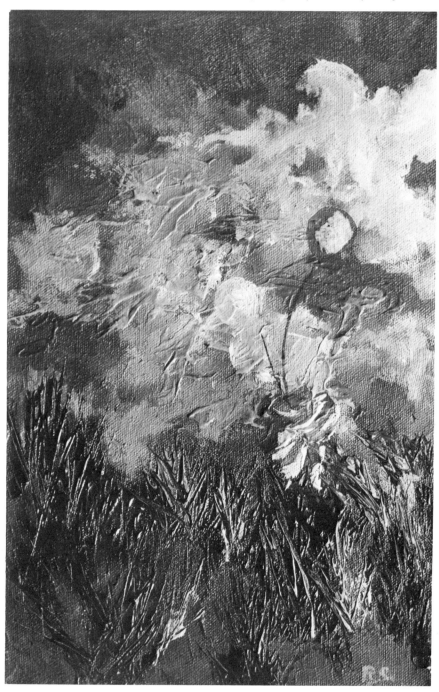

Sky and Grass *by Rene Smith, student at Warwick High School, Newport News, Virginia. Acrylic polymer on stretched canvas. The sky was painted using brushes. The grass with its textural quality was achieved by applying and manipulating the paint with a painting knife.*

Mixing Extenders and Aggregates with the Paint

For thick applications, the paint may be used just as it comes from its tube or container. However, the mixing of acrylic modeling paste or acrylic gel with it can give extra body, helpful for many heavy applications. Using gel or paste has economic value too, since neither is as expensive as the paints.

The modeling paste gives an excellent body or stand-up quality to the paints, but mixing it with them does change their color and tone. The acrylic gel gives added firmness to the paints as well as a buttery smoothness that makes application easier.

The proportions for mixing these extenders with the paints varies according to the consistency desired and the color used. Try using half extender and half paint when you start experimenting.

Many artists mix aggregates and foreign textural additives with the paints to achieve interesting patterns and textures. The acrylic paint forms a binding, flexible adhesive for these additives and when not used to the extent of mixing more additive than paint, their use is technically sound. As textural additives mixed and applied with the paint, their size must be relatively fine, since large, lumpy pieces make the paint application clumsy and difficult. Their selection and use are limited only by the artist's imagination, since many materials are readily available. The following are a few frequently used additives; sand, dirt, sawdust or filing dust from wood, metals, stones, plastics, and other materials; mashed or ground eggshells, seeds, small shells, and beads. Experimentation with these is discussed later in this chapter. Combining other materials and larger objects with paint is dealt with in Chapter 6.

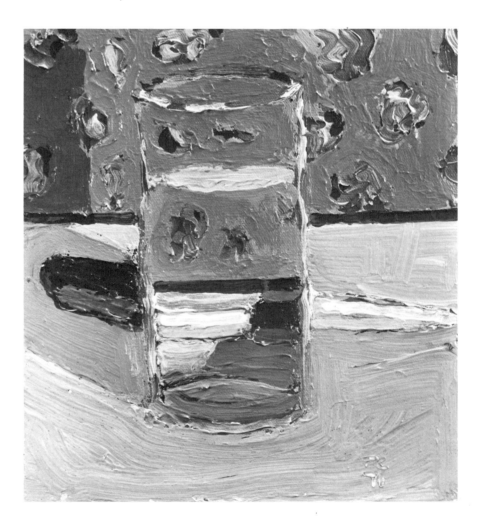

Still Life *by Tony Cacalano. Acrylic polymer on stretched canvas. Using acrylic polymer gel mixed with the paint as an extender and to give it additional body, artist Cacalano used thick and heavy applications of this mixture to create this study.*

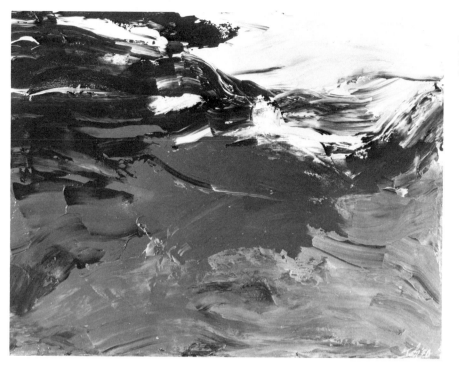

Abstraction *by John Matheson, student at Virginia Wesleyan College. Acrylic polymer on Masonite panel. The paint was mixed with acrylic polymer gel before it was thickly applied and blended with a painting knife.*

Suggested Experiments for Brush and Knife

The following brief experiments are intended to acquaint the beginner with the individual qualities of both the brush and knife when used for thick paint applications.

1. This is an experiment for the painting knife and uses a gesso-primed cardboard, hardboard panel, or canvas board no smaller than 12″ × 18″ as a working surface. Instead of using several painting knives, select a general purpose one and explore its varied uses. Instead of painting a picture, use one dark color and white and concentrate on how the knife can be used. It will be easier if beforehand you prepare ample amounts of both the dark color and white by mixing them with the gel or modeling paste.

 a. Using the flat blade of the knife as you would when icing a cake, spread the dark color thickly over about 1/4 of the test panel, striving for smoothness. While this area is wet, apply the white into it, experimenting with blending both smoothly and with knife strokes showing through.

 b. Instead of spreading, apply the paint in smaller, sculptured strokes, building and layering one into another.

 c. Using both the thin edge and the flat blade of the knife, scrape, sculpture, and manipulate the paint into forms of varying thickness and patterns of angles and curves.

 d. Create a variety of lines and textures by applying the paint with different kinds of strokes and by drawing into these wet layers of paint with the edge and point of the painting knife.

2. This experiment uses the brush with the same working surface and colors as in Exercise 1. Select for this exercise a Number 10 or 12 flat, stiff bristle brush. One size will suffice for experimenting, since larger and smaller ones are used in essentially the same way.

 a. Using the brush like a shovel, lift and apply the paint in thick, heavy strokes, covering about 1/4 of the working surface with the dark color. While this area is wet, manipulate the white into it with big sweeping strokes, striving for a smooth blending of tones in some places and using visible strokes in others.

 b. Instead of brooming or sweeping the paint onto the working surface as in part (a), lay on smaller, more articulate strokes, fitting and building one into the other without blending them.

 c. Create a variety of textures by applying the paint by stippling, slapping, and other texture-making motions. Create texture, designs, and lines by drawing and pressing the brush into thick layers of paint already applied to the surface.

Your First Picture Using Thick Paint

After experimenting with blending techniques and carrying out the knife and brush exercises, you are ready to approach your first major composition using thick applications of paint. The subject matter should be of your own selection. Working either abstractly or with a familiar simple subject is advisable so you can concentrate on the techniques of heavy paint application rather than on the problems of a difficult subject.

Do not work too large or complicated on this first one. A good size would be 18″ × 24″ to 24″ × 30″. Use both brushes and the painting knife to become further acquainted with their versatility.

Plan the composition first with sketches and notations for colors, basic lights, darks, and their locations to save time and unnecessary overpainting. Limit the colors to no more than four or five, not including white, to help simplify this first attempt.

Selecting a Working Surface

You are now acquainted through your experiments with the way various working surfaces receive paint. Unless there is a special reason for using a surface with unusual characteristics, your best choice would be stretched canvas, canvas board or gesso-primed hardboard panel. For special needs, consult the chart on working surfaces at the beginning of this chapter.

*Points to Consider Before
and While Working*

1. Review what you have learned about using brushes, painting knives, and other equipment.

2. To use the paint thickly, you will need to mix much more of it. It is helpful to mix large basic color batches with the extender beforehand, to be lightened or darkened as needed. A palette knife is usually the best implement for mixing.

3. The entire painting surface need not be covered with thick paint. Do not hesitate to use thinner paint for smaller areas and details.

4. Decide whether it will be easier to put smaller shapes, forms, and details on top of the larger background areas or to paint the backgrounds around them.

Getting Started

When your working surface has been selected, prepainting study and composition sketches completed, color and tone decisions made and their general location established, roughly sketch the composition on the working surface and start painting with confidence. Use whichever brush and knife seem appropriate for the subject or areas and continue to use them as long as they are doing the job. Select another only when the one you are using fails.

*Suggested Exercises Using
Thick Paint Applications*

1. Paint pictures on a variety of working surfaces, regardless of your preference for particular ones. Painting on a rigid panel offers quite a different feeling from painting on a stretched canvas with its taut and springy give. Paint application is also quite different on surfaces of various textures. Without experimenting and experience, it is impossible to develop personal favorites or to select working surfaces appropriate for special purposes.

2. Paint at least one picture using painting knives only and one in which only brushes are used.

3. Experiment with textural additives mixed into the paint. Various aggregates and textural additives described earlier in this chapter can give interest and create certain visual effects when used either throughout the entire composition or only in selected areas. Set up your own series of experiments with them or combine their use in suggested Exercises 1 and 2.

Acrylic Polymer in Thin Applications

Just as some artists prefer using paint in thick applications, others find more satisfaction using it thinly since they may easily move from soft blended edges to the clean-cut or hard edge in either single-layer or multiple-layer approaches.

This chapter examines and suggests exercises for "step painting" (one logical step-by-step approach to multiple-layer painting), for painting both in a free and loose and in a highly controlled or detailed manner, and for glazing. The blending techniques explained earlier are necessary skills for success in these studies.

*Brushes and Other Tools for
Thin Applications*

Brushes are the most versatile tools for applying paint thinly and are used exclusively by most artists. Other applicators, used for special textures and effects, include rollers, sponges, crumpled paper, and cloths. Although stiff bristle brushes are perhaps the most widely used, badger-hair and sable brushes are useful for applying thin, smooth washes and glazes. Pointed sables are necessary for achieving delicate modeling and the shadowing often associated with fine details.

Working Surfaces

Unless striving for special textural effects, select smooth or lightly textured working surfaces. For additional help, consult the chart on working surfaces at the beginning of this chapter.

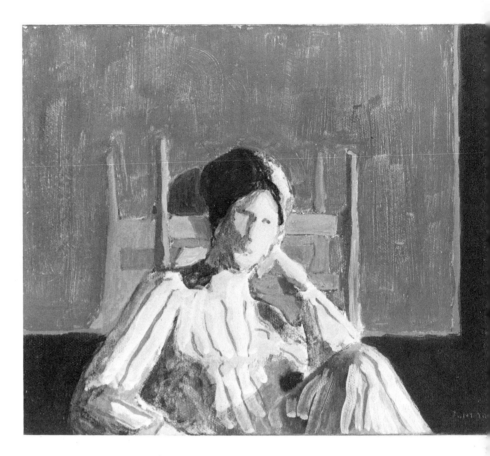

Resting Woman *by Tony Cacalano. Acrylic polymer on stretched canvas. Painting with thin mixtures of paint, Cacalano effects a "painterly" quality, enhanced by the texture of the canvas showing through the paint.*

Back Stairway *by Arthur Biehl. Acrylic polymer on tempered Masonite panel. Thin paint applications were used to create this dramatically realistic composition.*

The Step Method

There are several logical ways of building and completing paintings. They progress in various stages or steps, certain aspects being completed at each stage. The purpose of these methods is to help the artist plan and control the painting from beginning to end.

Although this method is a logical approach to picture building, all work produced this way does not have to be precise or highly detailed. This logical ordering of procedures lends itself just as readily to a free and expressionistic use of paint. Experiment with each way, then let personal choice direct you. The rapid drying quality of acrylic polymer makes it an ideal medium for painting in stages or multiple layers.

Above: Se!f Portrait *by Vicky Koshell, student at Menchville High School, Newport News, Virginia. Acrylic polymer on Upson Board. Student Koshell uses thin paint mixtures on the unprimed surface of this freestanding, life-sized figure cut from an Upson Board panel.*

Right: Confederate Soldier *by Malcolm Anglin, eight-year-old son of artist Betty Anglin. Thin paint applications were used for this picture in the single-layer approach to painting.*

Watchers by author. Acrylic polymer on
tempered Masonite panel. Thin paint mixtures
were used in various techniques of applica-
tion for this step method painting.

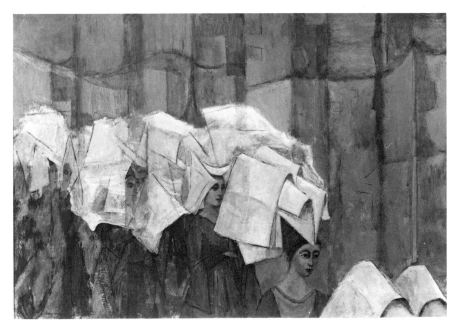

Procession *by Jean Craig. Acrylic polymer on Masonite panel. Successive paint layers applied in various techniques and thicknesses.*

Below: Deserted Farm *by author; Robert Maffin, owner. Acrylic polymer on tempered Masonite panel. This painting utilized the step method of careful planning and successive layerings of transparent and opaque paint mixtures.*

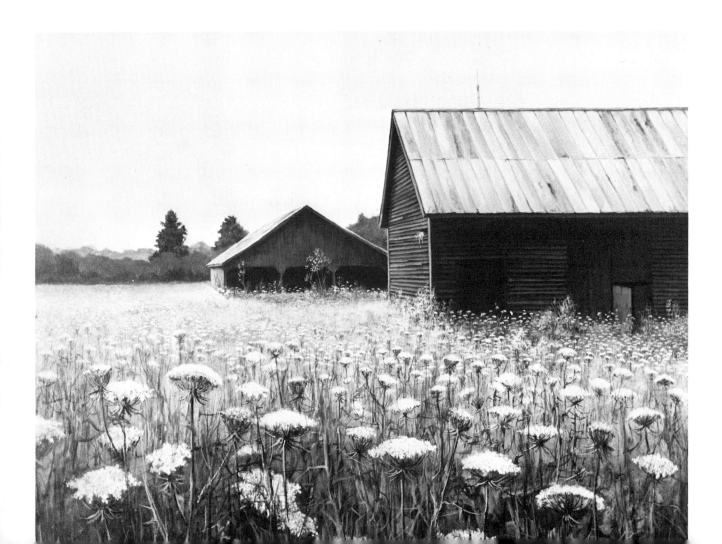

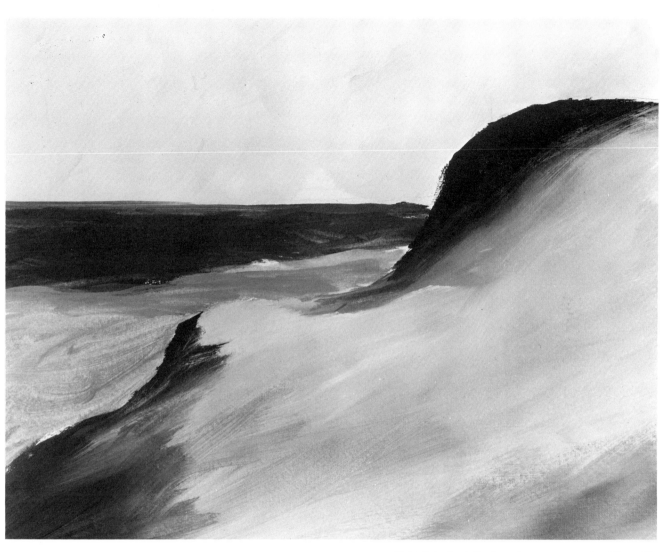

Stage One of painting by author on gesso primed Masonite.

Step One: This method of painting deals with the multiple-layer concept of under and overpainting, using opaque applications as well as transparent ones. Adjust your thinking to the idea of layering and to the importance of opaqueness.

a. Sketch or draw the subject on the working surface. If you feel a careful, detailed drawing is necessary, make it dark enough to show through the thin basic washes so as to avoid having to redraw it. Either a drawing pencil or a wash of acrylic thinned with the medium mix may be used to sketch the subject. Charcoal is acceptable if it is sprayed before painting with acrylic fixative or a thin mixture of medium and water. If the charcoal is not fixed, it smears and dirties the colors in thin paint mixtures. Avoid magic markers and felt-tipped pens; they are usually too dark and most often will bleed through any number of paint layers.

b. Forgetting for the moment about details and small areas, de-termine a basic tone and color for each of the large divisions and areas of the picture. With the medium mix as thinner, create thin paint mixtures and completely cover those areas, using conveniently large brushes. Strive to cover the entire working surface with some color at this stage.

c. Decide whether this is the best basic tone and color for each area; if not, change by painting over. If necessary, redraw any of the original guidelines or supply new ones.

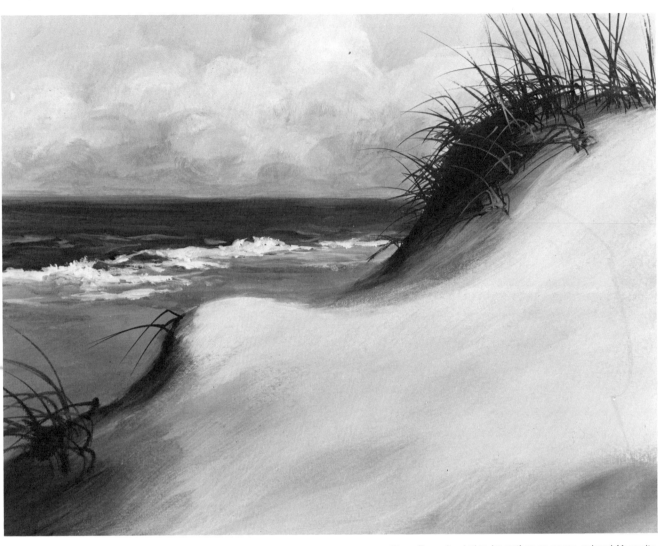

Stage Two of painting by author on gesso primed Masonite.

Step Two

a. The greatest amount of time and work will be spent on the picture during this stage. Most of the readjusting, correcting, and developing should be done now. Begin pulling the picture together by starting to model and shadow. Create form, color, and tone variation in these large areas by working lights and darks over the dried layer of basic tone. Use the blending methods most suitable to achieve soft edges where needed.

b. Paint in the basic tones of the smaller areas and shapes, and roughly model and shadow them. Begin to work in texture patterns and suggest some detail. Avoid becoming lost in finishing any area completely unless you must because small areas or shapes are going to be painted over parts of it. For example, at this stage it would be proper procedure to complete a sky with clouds and tone variations if objects such as trees, poles, wires and other details were to be added over it in the final stage. This is the time when many artists use glazes to add brilliance and depth and make subtle color and tonal changes. Any number of layers may be safely applied.

c. Work consistently to achieve the same stages of completion over the entire picture. Evaluate, change, adjust, and add new forms or shapes and paint out others if necessary, but establish every object and area in the position, tone, and color you wish in the completed picture. Take as long as needed to be sure of your decisions. Use large brushes as much as possible, but move to different sizes and types as needed to do the job.

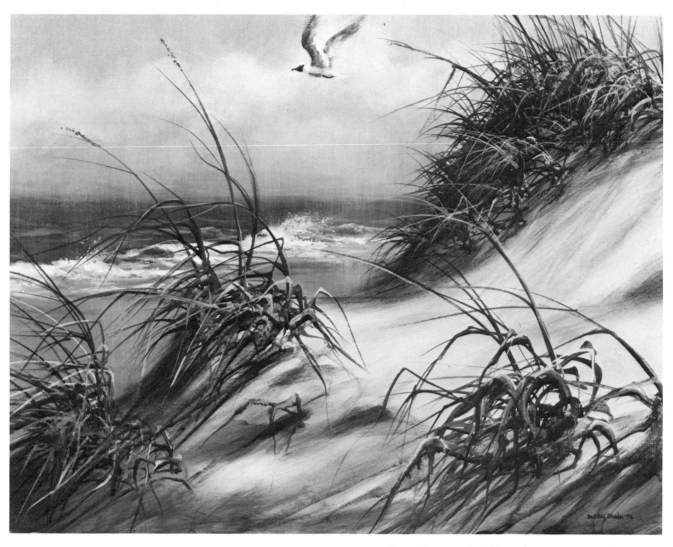

Stage Three of painting by author on gesso primed Masonite.

Step Three—The Final Stage

a. Making sure that all major adjustments are taken care of, decide how finished and detailed you want the picture and go to work completing it. Use small brushes if needed for the finest details, highlighting, shadowing, cleaning-up, blending, or sharpening of edges and forms.

b. Stop for frequent evaluations to keep the composition from becoming out of balance.

c. Leave the picture alone for a while, then take a fresh look at it, evaluating to see whether it is finished. Complete what is required, then leave it alone for a period of time. If your evaluations pronounce it finished, it is finished. Give it final protective coats of clear medium now, or wait until you are ready to frame or exhibit it.

Left: Butterfly *by John Caddy, Virginia Beach High School student, Virginia. Acrylic polymer on Masonite.*

Above: Stairway *by Edward G. Carson. Acrylic polymer on tempered Masonite panel. A skillful manipulation of thin paint mixtures with sable brushes, produced this clean, sharp, hard-edged picture.*

Achieving Special Effects

Special techniques for creating razor-sharp edges and other special methods of application and execution can be used to advantage in step painting.

Hard Edges and Lines

Hard edges can be painted with a brush using a thinned paint mixture and manipulating the brush in such a way that its tip or side edge leaves a smooth, unblended edge. Small pointed sable brushes can be used for small shapes and for touching up uneven edges. Some artists outline the shapes using a ruling or

A Rose is a Rose *by Cornelia Justice. Acrylic polymer on stretched canvas. A knowledgeable use of materials plus the skill of observation were required to render this enlarged study. Size: 26" x 30".*

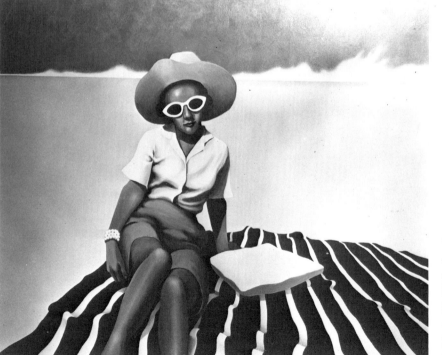

Watcher on the Beach *by author. Acrylic polymer on tempered Masonite panel. The paint was applied with both brush and sprayer. Areas not to be sprayed were masked off and protected by covering with tape and paper.*

Opposite: Interior with Flag *by Phyllis Houser. Acrylic polymer on stretched canvas. Careful brush work with thin paint mixtures produced this skillfully rendered composition.*

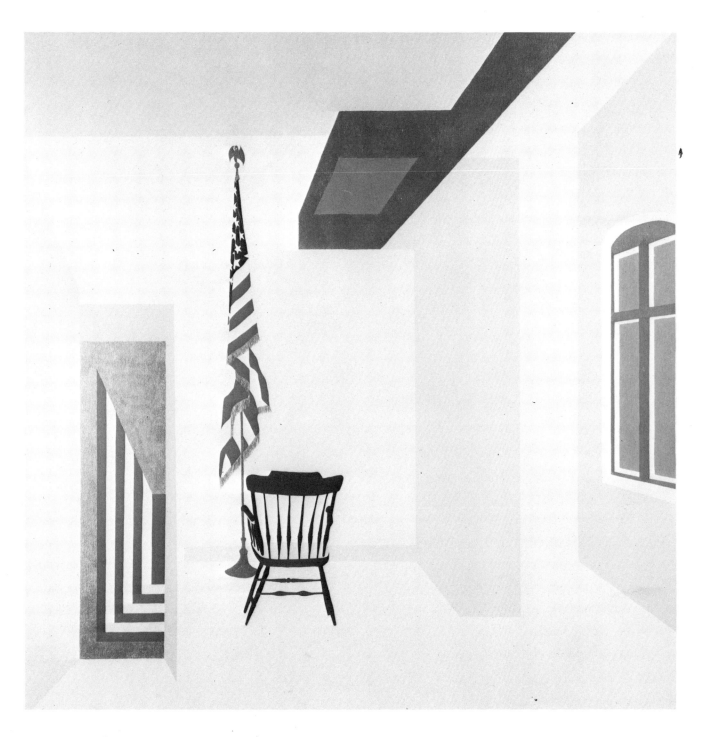

drafting pen filled with a very thin paint mixture. Razor-sharp edges are easy to make by using masking tape. Tape off the areas where the sharp edges are desired, pressing the tape down firmly to keep the paint from bleeding under. Paint over the taped area and let it dry before removing the tape. Large areas may be covered with tape and various shapes and designs cut and lifted from it with a razor blade or utility knife. Apply the paint over these cut-out areas, let it dry, and then remove the surrounding tape. Paint bleeds under the tape can be prevented by coating and sealing the tape edge with acrylic medium after it is pressed into place, before the paint is applied.

Sponges, Fabric, and Other Materials As Paint Applicators

Sponges, crumpled paper towels and fabrics, pieces of rugs, and other miscellaneous materials may be used to apply paint for special textural effects. Best results are achieved by using a dabbing motion.

Scratching the Painted Surface

Many unique linear and textural qualities can be achieved by scratching the dried paint surface. If done over several paint layers of different tone and color, it exposes these in an interesting way, depending upon the depth of the scratches and numbers of layers of paint. Razor blades, sharp pointed instruments, and sandpaper may be used for this purpose.

One Way of Solving The Problems of Fine Detail

One way to achieve complicated and fine detail in a complex design

Willow Oaks by Arthur Biehl; Dr. Thomas A. Matthews, owner. Acrylic polymer on tempered Masonite panel. A brilliant and gifted technition, artist Biehl writes concerning his painting technique: "The acrylic paint can be applied in a variety of ways, depending on the effect desired. The consistency of the paint ranges from thick to very thin washes. The tools also are quite varied, and besides the use of brushes of all kinds, I rely very heavily on a shaving brush for stippling large areas. Spatter techniques, sponges, rags, blotters, steel wool, sandpaper, needles, or any other tool that will do the job is used."

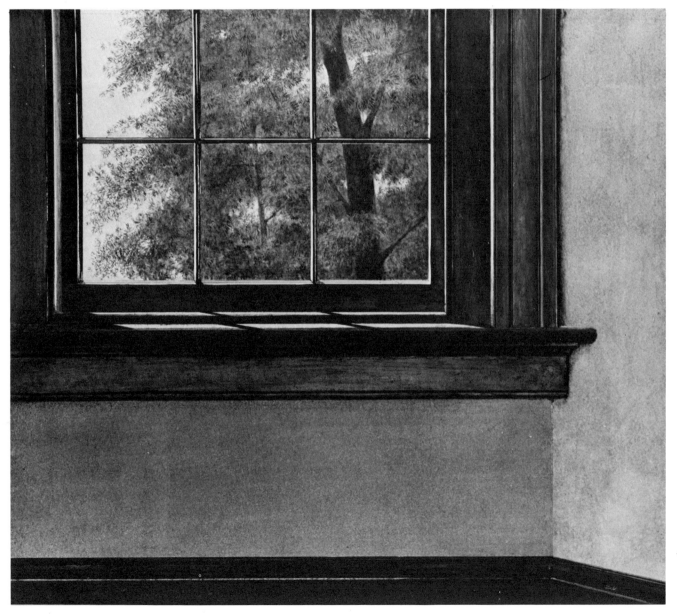

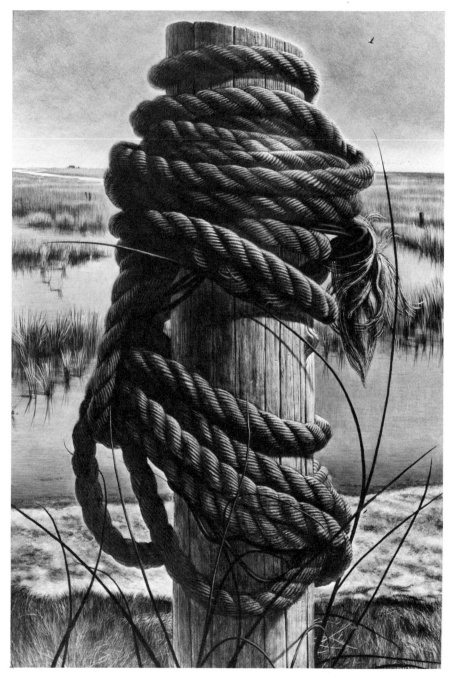

Silent Witness *by Allan Jones. Acrylic polymer on tempered Masonite. Starting with a complete charcoal drawing on an acrylic gesso primed surface, artist Jones created this picture using transparent glazes almost exclusively. A disciplined talent is required to produce the detailed finish depicted in this carefully planned and executed painting.*

or subject is to start with a dark detailed drawing done in pen and ink or brush and paint, and then work over this drawing with transparent applications of paint or glaze, finishing it with opaque highlights. This is basically a line and paint combination technique and is described more fully in Chapter 3. Other linear methods of depicting detail are introduced in that chapter.

Suggested Exercises Using the Step Method

1. Select a subject, make sketches, tone and color studies, and create a plan of action. Select a working surface appropriate for this method at least 24″ × 30″ or larger, and follow your work plan through the three steps. Strive to be as meticulous and detailed as possible.

2. Select a subject different from that of Exercise 1. Complete a step painting, making your prime objective in this exercise the free and loose application of paint.

3. Make several small test examples using the scratch technique, or incorporate it in Exercises 1 and 2.

4. Incorporate hard-edge techniques into a painting or experiment with them in separate test examples, using both brush and tape.

5. Experiment by applying paint with sponges, crumpled cloths, fabrics, rug scraps, and other miscellaneous materials.

Questions Frequently Asked about the Step Method of Painting

1. If the painting is completed and varnished with acrylic medium and you decide that it needs more painting, is it possible to add new paint applications?

Yes, any combination of layers of paint, glaze, and medium is technically possible and safe.

2. Why should all of the working surface be covered at the end of step one?

Because it forces you to decide on colors, and since this is a method of layering paint both over and under, the all-over basic color and tone is necessary as a foundation. The working surface may be left exposed if its tone and color is to appear exposed in the finished picture.

Sandwashed Dunes *by author (courtesy of the Seaside Gallery, Nags Head, North Carolina). Acrylic polymer on tempered Masonite. Except for small areas in the sky, sand, and water where opaque paint was used, this picture was painted almost entirely with multiple-layers of transparent glazes.*

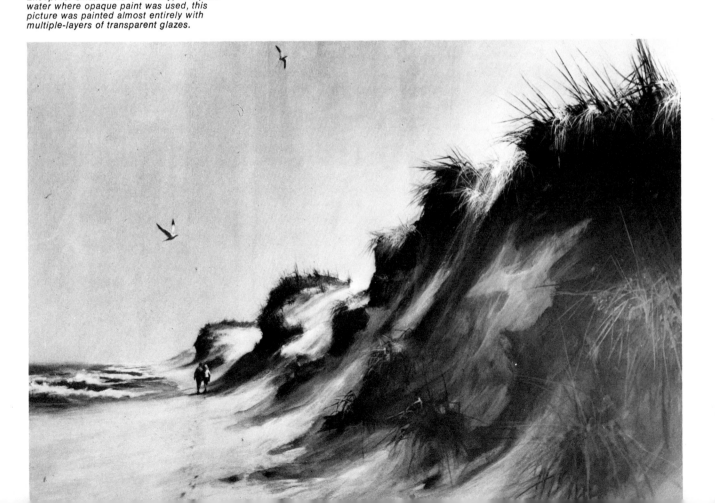

Glazing

A glaze is a transparent mixture of paint and gloss medium. It handles like paint and may be blended by using the wet-in-wet, the wet-blend, or the dry-brush techniques. Thick glazes may be produced by mixing paint with the gel medium. The difference between a glaze and a wash is that the full-strength liquid medium or gel, when mixed with the paint in a sufficient amount to produce a transparent mix or glaze, suspends the paint pigment in a clear, glass-like surrounding and retains this suspension when dry, producing a brilliant shine that refracts and reflects light. Even a transparent wash lacks this light-refracting quality because it does not suspend the colored pigment in a clear magnifying surrounding. A wash dries flat, the pigment particles piled one upon the other.

Almost any color, except white or colors with white mixed with them, will produce an adequate glaze when mixed with the gloss or gel medium. The matte medium will produce a transparent mix, but because of its lack of gloss and true clarity, it will not produce a clear, brilliant glaze.

Glazing is usually applied over basic tones, as in the second and final stages of step painting, to change tone and color and to add transparent brilliance and depth. Portrait painters, for example, frequently use this method to create soft transparent shadows, while landscape painters may use it for brilliant skies and colorful foliage. Since the value of the transparent glaze depends upon the reflection of the color and tone underneath it, glazes usually work best over light colors. However, shadows and tones of great depth may be achieved by glazing over dark colors. Experimenting will lead the individual to his own conclusions and ideas about glazing.

True transparent glazes cannot be achieved by mixing white or opaque colors with the mediums; but many interesting translucent, misty, and foggy effects are possible when enough medium is mixed with the color. When either the gloss or matte medium is mixed with the paints to produce glazes of any kind, it may give the mixture a milky appearance, but this will dry clear. Practice and experimentation will teach the amounts of medium and paint necessary to produce certain degrees of transparency.

Suggested Experiments for Glazing

1. Experiment with color happenings and tonal changes by taking a white gessoed panel and brushing thin layers of different colored transparent glazes one over the other. Wait for one layer to dry before applying another. To get an idea of other possibilities of glazing, experiment with various overglaze combinations, such as red over yellow, blue over green, red over blue, etc.

2. Use colored glazes to tint a black and white photograph or illustration from a magazine. This will acquaint you with the transparent tinting qualities and the tonal depth available with glazing. Work entirely transparently unless the whole picture becomes too dark; then light areas and highlights may be added opaquely. The object of this exercise is to add color, tone, and depth, while retaining the detail of the picture underneath. To do this, the glazes must be very transparent.

3. Paint a picture, either realistic or abstract, where the glazes are primarily used to produce brilliant color by glazing over white or light areas of underpainting. If your picture is realistic, select a subject where the brilliance of glazing can be used to advantage. Fall landscapes, colorful skies, and flowers are but a few examples of such brightly colored subjects.

4. Experiment with thick glazes, mixing the acrylic gel with the paint. Interesting stained-glass effects are possible with gel as the medium. It will remain milky for a longer time than the liquid medium, but it too will eventually dry clear.

Questions Frequently Asked About Glazing

1. When glazing, is it possible to dilute the medium with water rather than use it full strength?
It is possible, but the more water used in the mixture, the more it resembles a wash in appearance and handling. To get the true light-refracting brilliance, the paint pigments must be suspended in the clear medium and be surrounded by it. The full-strength gloss medium does this more efficiently.

2. Is it possible to achieve the effects of glazing by coating dried washes with clear gloss medium?
No. Even though the clear coatings of gloss medium may give some new life and vitality to the colors, it will not be a glaze or look like one, since it is a varnish-like coat sealing the colors rather than mixing with them.

3. Is it necessary to give a painting done with glazes a final varnish coat of medium when it is finished?
It is usually not necessary, but it will protect the painting's surface and give a uniform finish to the whole painting.

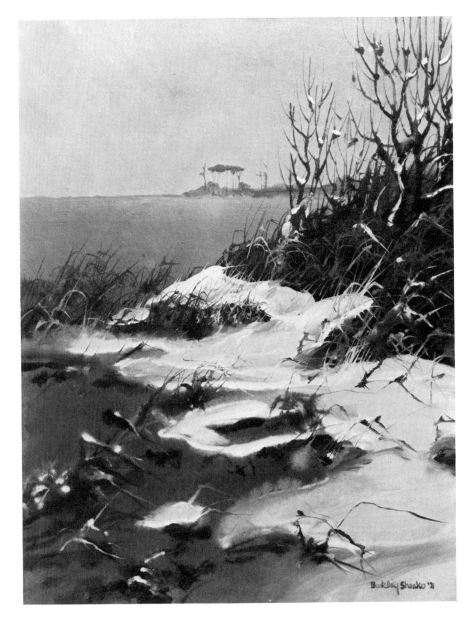

Last Snow of Winter *by author. Acrylic poly-*
mer on Upson Board panel. Thick and thin
paint applications are combined in this land-
scape. The unprimed surface was saturated
with water to facilitate blending. The large
background areas were roughed in with thin
paint mixtures and the thicker applications
were used primarily in the snow and grass.

Combining Thick and Thin Paint Applications

Although we are studying painting through experimenting separately with thick and thin paint applications, we should not conclude that using both in one picture is an unacceptable procedure. Many artists use thin washes in combination with thick, heavy applications. There are no rules for this kind of combination, but your sensitivity and personal opinions will guide your judgment.

One logical approach is to rough in the large areas of your picture with thin paint and washes, reserving the heavier paint applications with both brush and knife for special textural contrast in smaller areas and details. If you are serious about learning painting techniques, you should try combining thick and thin applications, including glazes. Each has virtues that can be used to advantage in a single composition. Perhaps it will be natural for you to combine them. If not, it is still a goal worth working for.

Final Varnish or Protective Coatings

When acrylic polymer paints are dry they have a naturally tough and durable finish. However, the finish is not impervious to wear and damage from scratching and other sources. Paintings executed with thick applications of paint need less protection than those done with thin applications and layers of wash and glaze. Coatings of clear gloss or matte mediums will protect the painting and give it a unified finish. Scratches on this clear skin are easily covered at any time with an additional coat.

These final varnish coatings may be applied by brushing or by spraying. If unthinned medium is used, apply it with a wide (3″ to 4″) fine-bristled house-painter's brush (or your largest artist's brush), working quickly over the entire painting surface using a crisscross, interlocking brush stroke to avoid long brush marks in the dried finish. If the painting has pronounced brush or knife marks or texture in its surface, follow these when applying the medium. The advantage of using the full strength, unthinned medium whenever possible is that one coat is sufficient protection. This usually dries with some brush marks visible.

Perfectly smooth brushed-on finishes may be achieved by using several coats of a mixture of medium thinned with water in proportions up to 3 parts water to 2 parts medium. More thinning might result in a weak film. Use the same brushing technique as when using the undiluted medium. For most purposes the mixture of 1/2 medium to 1/2 water will give good, smooth finishes.

For sprayed finishes, artist's air brushes, house-painter's sprayers, and those sprayers included with many vacuum cleaners may be used satisfactorily. For best results, considerable experimenting and practicing with various thinned mixtures in your particular sprayer should be done before using this finish on a painting. Straining the medium and

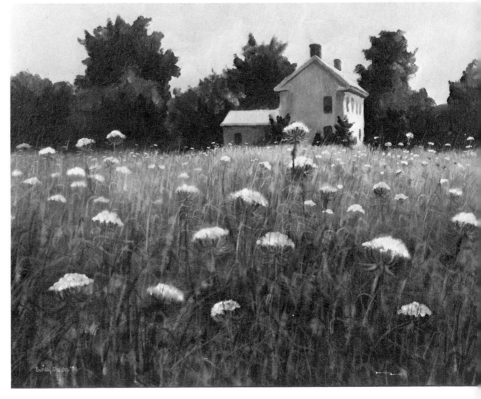

Study for Summer *by author. Acrylic polymer on Upson Board panel. Paintings executed in thin watercolor-like washes like this one may be protected with several coats of matte or gloss acrylic polymer medium and framed without glass.*

water mixture through a piece of narrow-gauge ladies' hosiery will give it a uniform consistency more likely to pass evenly through the sprayer without clogging. Several sprayed coats are necessary for adequate protection.

Matte medium gives a nonglossy finish, while the gloss medium retains a shine or gloss when it has dried. These may be mixed in any proportion to give the finish most appropriate to the picture.

While the matte medium does not produce a shiny surface when used as a final varnish, it does have a dulling effect when used over dark colors that is not noticeable over light or extremely bright colors. Many inexperienced artists are disappointed after having used matte medium as a final varnish. This dull, flattening quality is inherent in the matte medium. You cannot have true fidelity of color and tone depth, particularly in dark colors, unless a gloss finish is used. It is a good idea to experiment on test panels of both dark and light colors before deciding which type of finish to use and how to apply it. Although time-consuming, such experimentation will prevent much disappointment in the long run.

Angel *by Jack Witt. Acrylic polymer on a carved wooden panel. Many techniques are used to form this striking study. Portions of the composition are formed by carving. (The chisel marks are noticeable in the ears and about the shoulders and neck.) The cheeks, nose and lips are drawn and painted on paper and then glued to the surface in a collage technique. The whole composition is toned with thin acrylic polymer washes and protected with final coatings of clear acrylic medium.*

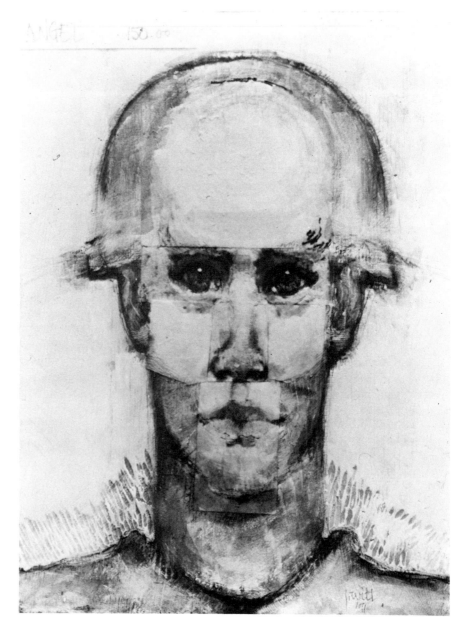

Acrylic Polymer in Line and Paint Combinations

Line is an important basic element in painting. When very noticeable or dominant, this pronounced linear quality may be described as a drawing-painting combination, or line and paint combination. The appearance varies with the working surface, the line quality, and the painting technique. Line is so frequently combined with painting that it will be considered here as a separate, basic technique, one which may use all of the primary methods of paint application from transparent and opaque water-colorlike washes to heavy impastos and glazes. The suggested exercises for line and paint presuppose a knowledge of primary techniques covered elsewhere in the text, although combining, extending, and varying them. Those generally unfamiliar with a particular technique may wish to refer to the appropriate section as the need occurs.

You will need the basic paints, brushes, and liquid and gel mediums suggested in Chapter 1 as well as other general equipment employed while practicing the basic painting techniques. In addition, you will need various drawing implements and media; just what kind and how many depend upon the number of experiments you do. The same is true for working surfaces, since a variety of experiments will be suggested.

Near The Summit *by Allan Jones. Acrylic polymer paint and line combination on water-color paper. For an interesting and unique combination of drawing and painting, Jones diluted liquid acrylic polymer medium with water, spread it on a sheet of plexiglass, sprinkled on powdered pigment color and pushed it around with a brush. He then placed a piece of water saturated water-color paper on top of this surface and pressed it down firmly before pulling it off with about five pauses (pulling from top to bottom). When dry, the details such as the tree and head were drawn with charcoal and highlighted with colored chalk.*

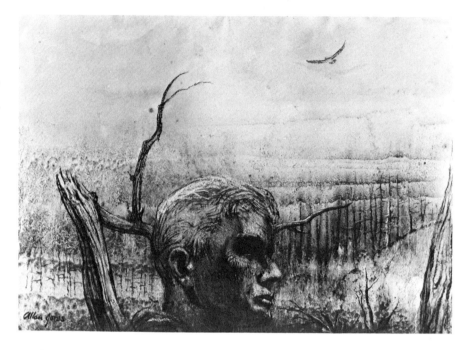

Dark lines are clearly visible when transparent washes are applied over them.

Basic Concepts of Line and Paint Combinations

The principles of transparent and opaque paint are as important here as in most other painting methods. Transparent mixtures of paint are often applied over a black or dark line drawing. Both light and dark lines may be drawn on top of applications of paint. Both the number of layers and the sequence in which you alternately draw and paint will depend upon the appearance and effect you wish to create.

Media and Tools Used for Drawing

Most of the traditional drawing implements and media may be incorporated with acrylic polymer. The following are often used.

1. Pencil
2. Charcoal
3. Pen and ink
4. Sharpened stick and ink
5. Brush and ink
6. Brush and paint
7. Felt-tipped and magic-marker type pens
8. Pastels and chalks
9. Wax crayons
10. Lithograph crayon
11. Ball-point pens

Reason for Using Certain Drawing Media

Unless sprayed with acrylic medium or fixed in some way, lines drawn with some media (for example, those made with charcoal, chalks, or water-soluble inks) smear or dissolve easily when paint is applied or washed over them. Results with these media are most satisfactory when they are used on top of dried paint applications. Waterproof inks, paints, wax crayons, and lithograph crayons may be used both over and under paint applications.

Bee by Edward G. Carson. Line and acrylic polymer wash on illustration board. This careful pen and ink study was tinted with color by applying acrylic polymer washes over the finished drawing.

EDWARD G. CARSON

Face of Grief *by Rene Smith, student at Warwick High School, Newport News, Virginia. Line and acrylic polymer wash on water-color paper. Transparent washes were used to give color and create form in this ink and sharpened stick drawing.*

The colors of inks and dyes used in many ball-point, felt-tipped, and magic-marker type pens are frequently impermanent and fade quite rapidly. Only those designated as permanent should be used. Drawings done with most of these will eventually bleed up through any number of opaque paint layers, so they should be applied only in those areas where their visible presence in the finished composition is intended.

Some waterproof drawing inks tend to smear or bleed slightly when washes are applied over them, particularly if a scrubbing motion is used in the application. A few drops of acrylic polymer medium stirred into the ink before using it will usually prevent this.

Working Surfaces for Line and Paint Combinations

The working surfaces suitable for these line and paint combinations include the whole range of traditional and experimental surfaces used for all painting techniques. The selection should be determined primarily by the painting technique selected for the drawing. For example, the line and wash technique would most appropriately employ paper and similar materials, since a wash is basically a water-color characteristic and can be most effectively used on these kinds of surfaces.

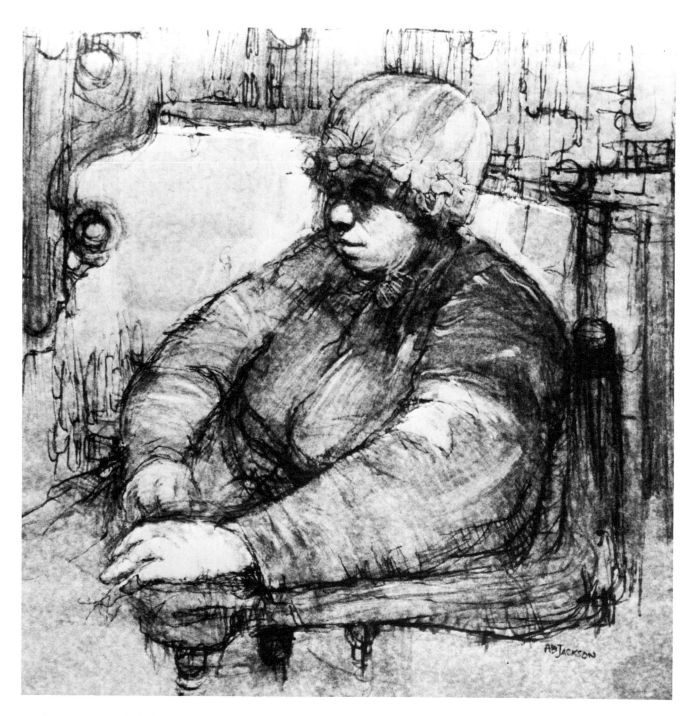

The Ample Sitter by A. B. Jackson, from
Porch People Series. Acrylic polymer, char-
coal, chalk combination. This sensitive study
was created by drawing with charcoal over
dried acrylic polymer washes and
highlighting with chalk.

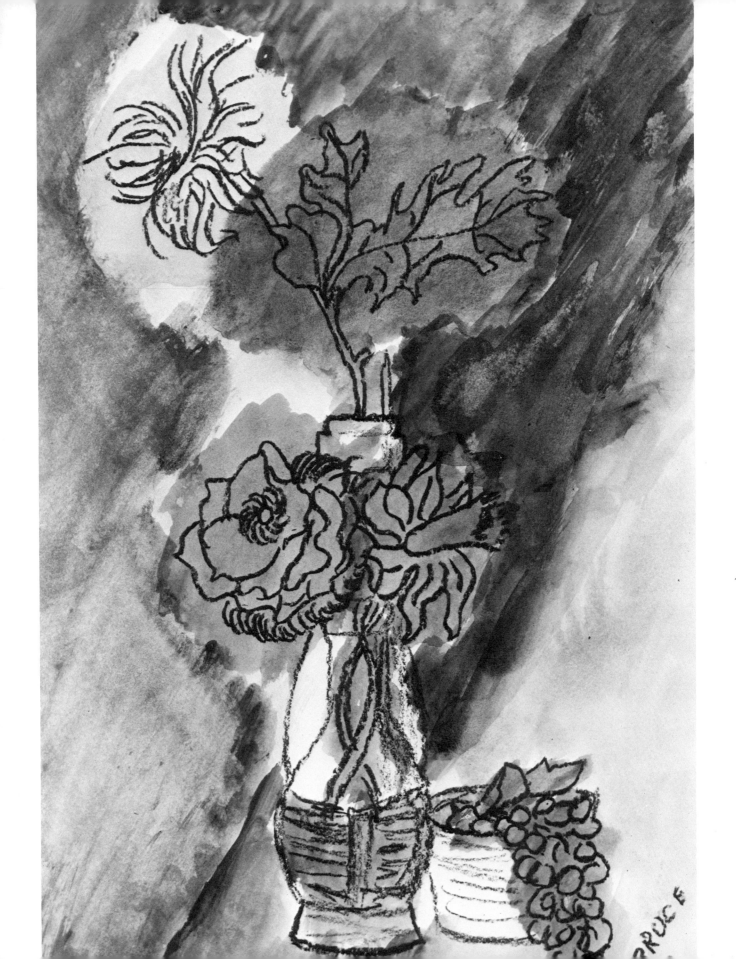

The Line and Wash Technique

The line and wash technique is essentially a combination of line drawing and water-color techniques executed on paper or paper-like working surfaces. The suggested exercises may be done on any convenient size, and unless specified otherwise, all-purpose paper, water-color paper, or illustration board may be used as the working surface.

An Experiment in Freedom and Movement

Select a dark or black waterproof drawing medium, one which can be manipulated easily, such as a ball-point pen or a felt-tipped marker. On a white surface, do a loose, free sketch using subjects that you think express movement. Landscapes and figures, both human and animal, are

good to use. Work rapidly, striving to capture action rather than detail. When the drawing is complete, select a few colors appropriate to the mood of the drawing and apply them freely in thin, transparent washes across and over the lines, leaving portions of the white surface in the background and drawing as accents and highlights. Allow some of the washes

Opposite: Floral Study *by Gruce Gordon, student at Warwick High School, Newport News, Virginia. Line and acrylic polymer wash on all-purpose paper. Both the black crayon drawing and the transparent acrylic polymer washes create their own pattern in this striking painting.*

Below: Still Life with Cow Skull *by Michaelene Cox, student at Warwick High School, Newport News, Virginia. Line and acrylic polymer wash on water-color paper.*

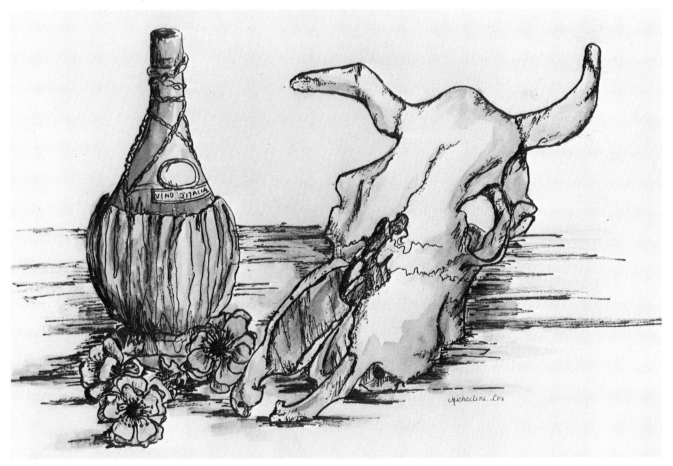

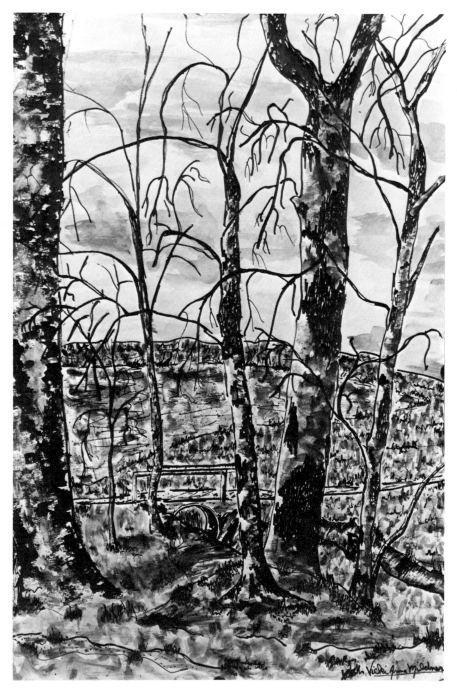

to flow through the drawing into the background rather than just filling in the drawings.

The objective here is to create a sense of freedom and movement in both drawing and wash by not confining the washes entirely within the drawn lines. If, after adding the washes, more lines seem to be needed, they may be added over the washes. Set a time limit of 20 to 30 minutes and work rapidly. Do several of these examples.

A Study in Description and Detail

With a pen or sharpened stick and waterproof ink, make a careful drawing of a subject that lends itself to fine detail. It could be a still life, an object study, or an architectural rendering. Use transparent washes in a descriptive way, keeping them more or less within the outlines of the drawing.

Your goal is to achieve a detailed drawing that dominates the picture, using the washes as descriptive tints. Set yourself no time limit on this problem. Concentrate on getting as much detail as possible. Those not familiar with the technique of stick drawing will find that a sharpened stick, dried twig, or wooden brush handle makes an excellent drawing pen capable of sensitively making a variety of lines suitable for drawings with considerable detail. Conventional metal pen points that fit into a handle or staff and are capable of producing fine lines, and some ballpoint pens are also suitable.

Winter Trees *by Vicki Anne Mildner, student at Virginia Wesleyan College. Line and acrylic polymer wash on all-purpose paper. The transparent washes were applied in a broken color, impressionistic technique over an ink drawing.*

Imaginative picture using ink lines drawn over dried runs and bleeds was the creation of a student at Warwick High School, Newport News, Virginia.

Lines over Runs and Bleeds

As in the wet water-color technique, saturate a piece of paper with water and then blob or drip thin washes of color onto the surface, allowing them to run and bleed in random manner. Tilt the paper occasionally to facilitate the blending. When dry, study the shapes and patterns from all sides, and then outline the realistic or abstract patterns suggested by the shapes of the runs and bleeds, changing and adjusting the drawing to create the image you see emerging.

The objective is to allow the watery shapes to suggest designs and subjects to be elaborated into compositions with the drawing. Strive for contrast between the soft, blending quality of the washes and the crispness of the drawn lines. Both transparent and opaque washes may be used when the lines are to be drawn over them.

For variation, you may absorb or lift random shapes from a wet surface of blended washes with crumpled dry cloths, paper towels, or napkins, creating a patterned background for the drawing.

Since backgrounds for this technique are easily and quickly produced, you should do a number of them during one working session, using different colors and approaches. When they are dry, experiment by drawing on them with many media, such as pencils, crayons, and chalks, as well as pen and ink.

As another variation of this method, saturate with water a smear-proof drawing done on paper, and then bleed thin, transparent washes into and over it in a descriptive, realistic, or abstract way.

Opaque Wash and Line

A quite different approach consists of combining line with opaque, thick washes instead of transparent ones. A crayon with enough wax content to repel the washes or a soft lithograph crayon or pencil, for instance, is ideal for this technique. The wax in the crayon resists or rolls away the washes, allowing free application directly over and across the drawing without covering it. Facilitated by the rapid drying of acrylic polymer paints, successive layering of both line and wash with heavy impasto applications may be accomplished. Since the soft lithograph crayon can be dis-solved by water, the drawing may be corrected at any time by scrubbing it out with a firm, wet brush.

Before attempting a complex com-position, experiment with several quick studies to get the feel of wash-ing over the wax lines and of layer-ing, adjusting, and scrubbing.

Felt or plastic-tipped magic-marker pens may be used, as well as wax crayons, for variety, or if lithograph crayons are not available. Having its own characteristics, of course, each kind of drawing implement results in a picture different from that produced by others.

Variations of the Opaque Wash and Line Technique

This method, which incorporates brush drawing as well as other draw-ing media, is effective on a variety of working surfaces. Heavy paint appli-cations may be used throughout the whole composition. Exercises to aid in understanding the many variations of this method should include experi-mentation in various sizes on working surfaces such as tag board, both primed and unprimed chip board, Upson Board, and Masonite, as well as canvas and canvasboard.

Linear Resist and Wash

This technique uses to advantage the ability of wax to throw off or resist the watery paint washes applied over it. For this technique, the drawing is made on white paper with a white crayon or a sliver cut from a cake of paraffin. Thin dark washes are then brushed quickly and lightly over the drawing, resulting in an intaglio effect of light linear detail on darker back-ground.

Press down firmly while drawing to assure a good deposit of wax. Ap-ply the washes quickly and lightly to prevent the drawing from being scrubbed away.

Washes may also be applied over drawings made with colored crayons. This variation offers numerous possi-bilities and combinations, including drawing on top of both transparent and opaque backgrounds, as in the method of opaque wash and line.

Opposite: Sunday Afternoon *by author. Line and acrylic polymer wash on Upson Board. The drawing was done over a dried opaque, acrylic polymer wash with a lithograph crayon. Both transparent and opaque washes were applied into and over the drawing.*

Right: Study for Summer *by author. Line and acrylic polymer wash on Upson Board. A lithograph crayon was used in combination with opaque and transparent washes.*

Use of Glaze

There are many ways of combining line with glaze. A good example is the stained-glass effect resulting when strong dark outlines are used around transparent glazed shapes. A true glaze is transparent, and greater clarity and luminosity are achieved if the more transparent colors are used. Mix undiluted gloss medium with the paints for thin glaze applications, gel medium for thick. Test experimental mixtures of various proportions on a white surface before using them in order to discover the principles of glazing and gain a general idea of how the colors will appear in the finished picture. Line and glaze combinations are possible on many kinds of working surfaces. Experiment with them in different sizes.

Brush Drawing and Glaze

For this study, use a smooth white surface of canvas or gesso-primed chip board, Upson Board, or Masonite. A size of at least 18″ × 24″ will give practice in using glazes over large areas. With a brush and a thin mixture of black paint, draw a picture using predominantly heavy, wide lines. When this is dry, apply colored glazes. Strive for a flat-patterned effect as in a stained-glass window or mosaic. Select a subject that you think is appropriate for this technique. Some artists use this method for producing strong, brilliantly glowing abstractions.

As variations of this approach, brush and ink may be used on illustration board or paper. Wide-tipped markers may be used on any working surface. Make sure of their permanency before using them and be sure that they will not smear when the glaze is applied. Colored glazes may be applied to drawings, just as in the line and wash approach. The appearance will not be the same, however, because of the clarity and brilliance of the glazes.

Thick Glazes and the Extruded Line Process

For an unusual three-dimensional quality in both the glaze and the line, one that actually simulates stained glass, create a black extruded line drawing and fill the white spaces between the lines with thick colored glazes made with acrylic polymer gel and applied with a palette knife. Those not familiar with the extruded line process will find an explanation in the next chapter. A canvas board or primed panel with some firmness and density is the best choice for this undertaking.

Final Varnish or Protective Coatings

The same logical procedures are used for varnishing and protecting works done in these techniques as for those done in other methods with acrylic polymer. Some works done in line and paint combination techniques will require special consideration because of certain drawing media used in them. Those with chalk or charcoal drawn on them are best protected under glass. They can be fixed by spraying with a mixture of medium and water, but there is the danger of drastically changing their appearance in the process. Sometimes pictures containing lines made with crayons and lithograph crayons are difficult to coat with medium. Since both gloss and matte medium contain water, the wax in the crayons tends to repel them. Experiment with small sketches before attempting to varnish a major picture. Sprayed finishes and those that are applied with gentle blobbing motions using undiluted liquid medium appear to give the best results for this type of picture. Almost all others may be treated like other acrylic polymer paintings.

Opposite: Vertebra *by Allan Jones. Charcoal and acrylic polymer glaze combination on water-color paper. The drawing was sprayed with acrylic spray and allowed to dry to prevent smearing when the glazes were applied. Touches of light, opaque acrylic polymer paint were used for the highlights.*

Abstraction by *Thelma Akers*. Acrylic polymer on Upson Board panel. The unusual relief quality was achieved by building shapes with modeling paste and then painting over them.

Acrylic Polymer in Relief Painting

Relief painting is simply the use of acrylic modeling paste on a working surface to create a low sculptured relief over which paint is applied.

Since this method deals with heavy sculptural and textural applications, its finished appearance is closely related to conventional impasto, or regular thick-painting procedures, as well as to collage.

Building with modeling paste and then painting over it is much less expensive than building with paint. Moreover, for building heavy forms, acrylic modeling paste has body with a quality and density more suitable than that of paint and can more easily achieve the relief with less shrinkage in the process.

Necessary Equipment and Supplies for the Relief Method

The basic materials, supplies, and equipment needed for experimenting with this method are those with which you are already familiar. The acrylic paints, mediums, gels, brushes, and painting knives used in the thick and thin methods of painting will suffice. A can of acrylic modeling paste or extender will be required, plus an empty squirt bottle, the kind used in the kitchen for ketchup and mustard, or an empty plastic household or shop glue bottle with a squirt or squeeze nose applicator. This will be filled with a modeling paste mixture and used in the extruded line technique. An ice pick or similar pointed instrument will complete the list. The working surfaces may be of canvas, canvas boards, wood, and hardboard panels. Other equipment, including putty knives, small trowels, and spa-

tulas, may be needed for deeper, more specialized involvement with this method.

The Acrylic Polymer Modeling Paste

Most manufacturers of brand-name artist's acrylic polymer paint produce acrylic modeling paste, or extender as it is sometimes called. Ingredients and handling qualities are not the same for all brands. Some are thick, others relatively thin; some dry very hard, others remain more flexible. All of them are adequate and suitable for permanent, durable results, and most of them may be mixed with water or acrylic mediums and gels to produce a mixture suitable for most purposes.

If artist's acrylic modeling paste is not available, most hardware stores carry small cans of an acrylic or vinyl-base spackling paste or compound intended for filling cracks, holes, or seams in dry wall construction. While not compounded as an artist's material, it may be used. Do not use oil-base putty or glazing compound because the oil is not compatible with water-base acrylic polymer paints.

The Wind Babies *by author. Acrylic polymer on tempered Masonite. The main movements for this picture were etched directly into the surface of the Masonite by scratching with an ice pick. More movements and texture were added by building lightly with acrylic polymer modeling paste, applied and manipulated with a palette knife. Paint and glazes were added over top of this to give the composition color, tone and detail.*

Working-Surface Materials for the Relief Method

A strong material with a light to moderately textured surface is best for small, general relief-painting purposes. For additional help in selecting a working surface suited for your purposes, consult the chart in Chapter 2. A textured surface will grip the modeling paste and hold it firmly and permanently when dry. Strength is important in the material used as the working surface. Heavy papers, cardboards, and stretched canvas, although adequate for small experiments with light build-ups, do not have the firmness, density, and strength necessary to support large, heavy masses or low sculptural relief. For these, tempered Masonite, other hardboards, wood, or canvas backed with such materials is best.

The heavier build-ups of modeling paste require a good textured surface underneath. Scratching or scoring a wooden or hardboard surface with a sharp instrument is recommended for those areas that will be under the thickest and heaviest relief. The rough side of Masonite is an excellent surface for holding the modeling paste. Build-ups 3/8″ thick or more are considered heavy and require a rough working surface.

The working surface may be coated with acrylic gesso or, if you choose, used without sealing or priming. A textured working surface may also be created with the gesso. See Chapter 2 for a description of this process. Large works in sizes exceeding 60″ require the extra support of framing or bracing in the back to prevent warping.

A young high school student applies paint to a relief of acrylic modeling paste on a canvas board panel.

Brushes and Painting Knives for Building the Relief

Most of the acrylic modeling pastes are too heavy and viscous to be applied and manipulated easily with brushes. For most practical purposes, the brush is used for textures, while painting knives and spatulas do the real job of building and forming.

The medium-sized, general-purpose painting knife, with its springy but firm tapering blade, can do most of the applying and building. Other available and frequently used tools include butter knives, putty knives, table knives, spatulas of various kinds, clay modeling and sculpturing tools, and an infinite variety of painting and palette knives.

The general-purpose painting knife is a good tool to start with; others may be added when necessary and for convenience.

Be sure to keep all knives, brushes, and working tools moist while using them. Clean and wipe them when finished. Dried paint and modeling paste adhered to them make them difficult to use. They may be cleaned by scraping or slicing with a single-edge razor blade or utility knife and then polished with fine sandpaper or steel wool.

How Many Winds by Cornelia Justice. Oil over acrylic relief on stretched canvas. The artist used rags, newspapers and brushes to apply the paint over the textural relief background of acrylic polymer modeling paste.

Procedures for Application and Building

Building a low relief is similar to icing and decorating a cake or making a sophisticated mud pie. As in other methods of painting, the manner can be sharp, cleanly delineated, and precise or loose, free, and unrestricted. Personal taste and intent will dictate the manner and will determine whether the work will be realistic or abstract. This method lends itself to a variety of approaches.

In most cases, when working with relief painting it is best to have the design for the composition well-planned and drawn on the working surface, since changing and removing dried areas of modeling paste can prove frustrating and difficult, requiring scraping, cutting, and sometimes chiseling.

The relief does not have to be finished in one application. Successive additional layers may be applied in almost unlimited numbers. Some subjects and situations lend themselves to a single-layer, impasto approach, while others are more complex and require the multiple-layer approach.

To start, scoop up a blade full of modeling paste and trowel it onto the working surface, following and forming the shapes drawn there, using the flat back side of the blade to press, pat, and form. Sculpture small and isolated forms by applying and shaping small amounts of the paste with the tip of the knife blade. Larger areas may be formed by applying thick, flat layers and then pressing and shaping the paste into the forms required, incising lines and adding textures as needed.

The Squirt Bottle and the Extruded Line Technique

Extruded lines are achieved by pressing or squirting a line or bead of modeling paste from a squirt bottle or similar device, such as a pastry tube. This technique produces raised, three-dimensional lines that may be modified in many ways for painting and sculpture, as well as for frame-making and printing.

Several kinds of container applicators may be used for this technique. The applicator should be easy to fill, and must be fitted with a nose or nozzle dispenser through which the modeling paste may be easily squeezed. For this purpose, the common plastic household or shop glue bottle with a nozzle or nose is ideal. The plastic nozzle may be cut shorter to enlarge the hole and produce larger extruded lines. When clogged, it is easy to clean out with an ice pick, or similar instrument. Plastic ketchup and mustard squeeze bottles also make effective dispensers, as do the variety of pastry tubes used in decorating cakes.

A Paste Mixture That Will Flow

For the extruded line, modeling paste is needed in a mixture that will flow easily through the nozzle but retain enough body to remain in a bead or three-dimensional line until dry.

Fill your container about halfway with modeling paste, replace the nozzle, and try squeezing a line. If the paste refuses to flow easily, your mixture is too thick. Thin it with a mixture of half acrylic liquid medium and half water until the results are satisfactory. Make sure that your final formula is stirred and mixed to an even consistency. You may also obtain good results by diluting the paste with acrylic gesso or acrylic gel medium. Experiment to find the best mixture for your purposes.

It is possible to have on hand several squeeze bottle dispensers filled with paste mixture, each with a different diameter hole in the nozzle for producing lines of different thickness. Some artists add paint to the paste for color and execute extruded line drawings on paper, hard board, or other working surfaces. When dry, they may be inked and printed like a block print, put in an etching press, or treated like a stone rubbing. These processes are covered in Chapter 7.

Before working, to prevent air pockets in the paste mix from interrupting the smooth flow of lines during squeezing, hold the container vertically, nose down, and tap it firmly several times against a solid surface. Use a downward motion and let the end of the nozzle be the point of impact. Repeat this process whenever the squeezed material begins to show signs of containing air.

*Suggested Building Exercises
Using the Knife and Extruded
Line Technique*

These exercises need not be larger than 12″ × 18″. For the working surface, Masonite or a similar hardboard Upson Board with a slightly textured gesso surface, or canvas board will be best. Though not ideal, if used no larger than 20″, chip board with both sides coated with gesso to prevent warping is economical and provides a satisfactory surface.

These exercises are designed primarily to develop skills and an understanding of building techniques. They may be finished by painting with acrylic polymer paints, using the techniques suggested in this chapter.

In these studies, as in any compositions involving relief painting, the three-dimensional forms do not have to cover the working surface completely. They may occur in varying depths with parts of the working surface exposed. Use as many layers

Opposite: Osprey's Nest *by author. Acrylic polymer on tempered Masonite. The tree and nest forms were built up with acrylic polymer modeling paste pefore painting. A palette knife was used to apply the paste for the tree form and the extruded line technique was used for the nest.*

Above: Detail of nest from painting Osprey's Nest, *showing extruded line technique.*

and applications as needed to complete the composition as you visualize it. Since these are skill-building exercises, it is best to work quickly, first drawing the design on the working surface as a guide.

1. Using the painting knife and related tools, create an abstract design of geometric shapes and forms, with texture in some places for visual interest. Make clean-cut precision and neatness your main goal in this exercise.

2. Select a simple realistic subject and use a very free, loose manner of employing the knife in the building processes. Allow this impressionistic freedom to be the main goal in this exercise.

3. Create an abstract linear design using only the extruded line. It could be a design in which the lines are interwoven into rhythmic, swirling masses, or it might be a more formal geometric design.

4. Select a realistic subject that you think is appropriate and render it entirely in extruded line. The rendering may be a simple use of descriptive lines or a complex study of built-up and interwoven ones.

5. Create a relief composition in which you combine both knife building and extruded line processes. Try to use each appropriately, building the heavier masses and forms with the knife and using the extruded line for linear effects and designs.

Opposite: Detail from an acrylic polymer relief painting by Thelma Akers, showing dry brush and highlighting effects. Scratching into the dried paint layers with sandpaper created some of the textural lines.

Above: Man's Mark by Valfred Thelin. Acrylic polymer on stretched canvas. Acrylic polymer modeling paste was applied over a textured

acrylic polymer gesso surface, using applicators cut from cardboard. During the building process water was spattered on the forms causing small craters to appear on the surface of the modeling paste. When dry, multiple layers of transparent thin glazes were applied and finished by dry brushing and highlighting with opaque paint. Some portions of the built-up forms are ½″ thick.

Sealing the Relief before Painting

The relief may be painted as soon as it is dry. Covering it with a coat of undiluted gloss or matte medium or gesso is recommended to seal all cracks and give the surface a protective skin, holding areas and particles not firmly attached. These coatings give a uniform surface that receives paint more easily. If a colored undercoat is to be used in the painting process, it will act as the sealing coat.

Methods of Painting the Relief

The Traditional Method

In this method the relief is painted exactly like a traditional or conventional painting. The paints are employed in the same way, and the finished appearance of the work is similar to a traditional picture with very thick paint applications. Some experimenting with the various techniques of paint application on raised and built-up forms is necessary in order to understand and practice them effectively. The modeling-paste exercises involving building with the knife and extruded line may be used for practicing these techniques.

The Underpainting, Dry-Brush, and Highlighting Methods

By using dry-brush and highlighting techniques over dark underpainting, unique effects of texture and tone can be achieved, thereby enhancing and emphasizing the three-dimensional qualities.

Coat the entire composition with black or a very dark color, making sure that every crack, undercut, and crevice is filled and covered. When this undercoat is dry, apply your selected colors, using a dry-brush technique in all areas. The paint will adhere to the high places and allow the dark undercoat to show in the crevices, valleys, and low places. As a final touch, added depth may be achieved by highlighting with the flat side of a stiff bristle brush, dragging whites and very light colors across and along the tops of the highest ridges and forms.

Using Glazes in Relief Painting

The use of glazes in relief painting has the same value as in any type of painting where transparent color brilliance and tonal depth are desired. Their use has already been explained in Chapter 2.

Putting a Protective Finish or Final Acrylic Varnish on the Completed Relief Painting

As on many acrylic paintings, the use of a final coat of clear gloss or matte medium is optional. It does offer added strength and unity of surface quality. Most artists use it for those reasons. Additional information on finishing and protecting completed works may be found in Chapter 2.

Questions Frequently Asked about Relief Painting

1. Is it possible to mix the paints with the modeling paste, thereby creating a colored relief in one operation?
Yes, it is possible and some artists do. Most of them, however, do not because frequently the mixture of paint and paste does not give the quality of color they want. Many who have tried this also find that in concentrating on getting the correct tonal and color qualities for the composition, the relief quality usually suffers.

2. Does a relief painting last as long as paintings done in thinner methods?
Generally yes, if it is executed properly and sealed and bonded firmly to a durable, rigid working surface and support.

Additional Methods of Paint Application

There are numerous methods of applying paint that vary from the traditional ones of brush and knife. These include spraying, dripping, spattering, running, and rolling. Descriptions of these processes are included for the purpose of broadening the expressive possibilities available to the artist, and experimentation with them is suggested.

Spraying

The soft blended quality of a sprayed surface with its wide range of tonal variation and gradation has an optical quality different from and impossible to achieve by any other method. Its possibilities range from very fine, almost imperceptible mists of paint to a noticeably grainy or even a spattered appearance. The spray applicators that may be employed for the various effects include window-washer-type atomizers, house-paint sprayers, the spray attachments available for most vacuum cleaners, the artist's air brush, and other spray devices. Some of these sprayers have degrees of spray control; others have little or none.

Depending upon your objectives, surprisingly good results may be achieved through spraying, provided proper care is used in the preparation as well as in the execution. Spraying paint applications can be an extremely frustrating operation. One must learn to spray lightly, not lingering on one area, and to use many coats to avoid undesirable runs and puddles. In some instances, a single faulty run can cause an entire area to be repainted with many layers. To avoid this, much experimentation is necessary. Depending upon the sprayer used and the desired results, the surfaces to be sprayed could be positioned flat, tilted, or upright.

Since fine acrylic polymer paint spray can fill an entire room and produce paint flecks that fall upon everything in the immediate area, those areas and objects that could be damaged from paint spray should be protected by removing and covering them. For safety's sake, spray in a well-ventilated room or outside, and avoid prolonged breathing of the spray. Many artists wear a mask if the spraying is to be prolonged.

Clogging of the sprayer's nozzle or orifice can become a problem, especially if the sprayer is used over a long period of time. Plunging the sprayer's nozzle into water while changing colors or waiting for areas to dry can prove helpful. Frequent scrubbing of the nozzle may also be necessary to prevent dried paint from clogging the sprayer. Use a rough brush and soap and water or a solvent such as lacquer thinner.

Use water for thinning the paints. Keep adding water until the mixture blows easily through the sprayer. If the mixture becomes extremely thin, add a small amount of acrylic polymer medium to aid the mixture in adhering to the painting surface. Straining the final mixture through a piece of fine mesh ladies' hosiery will give a uniform mixture and help prevent sprayer clogging.

The Storm Watcher *by author. (Courtesy of the Seaside Gallery, Nags Head, North Carolina.) Acrylic polymer on Masonite. The soft, blended quality of the sky was achieved by spraying thin applications of paint with an airbrush. The remainder of the picture was painted with brushes, employing conventional painting techniques.*

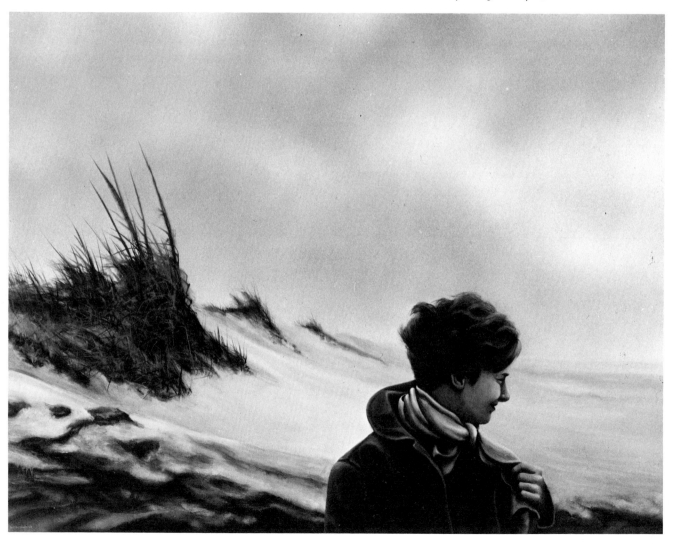

Abstraction *by Fae Zetlin. Acrylic polymer on stretched canvas. In combinations of multiple layers of thin paint mixtures, artist Zetlin uses highly controlled dripping, spraying and spattering techniques to achieve effects of optical vibration.*

Dripping, Spattering, and Running

The terms *dripping, spattering,* and *running* are descriptive of their processes. These techniques may be combined and varied by the use of a number of tools and instruments.

These processes are listed together since their methods and resulting appearance are interrelated.

Dripping may be done simply by pouring the thinned paint from a con-

venient container onto a flat horizontal working surface. Jars and cans with holes punched in their tops make efficient applicators for dripping or creating linear trails of paint.

GARY SEAY 71

Right: Abstraction *by Gary Sea, student at Virginia Wesleyan College. Acrylic polymer on stretched canvas. Spray and drip techniques were used to create this unusual composition.*

Opposite: Porch People Composite *by A. B. Jackson. Acrylic polymer-oil combination on stretched canvas. Artist Jackson painted the basic color and tone structure of this painting with acrylic polymer paints, and then used glazes of oil paint to refine the forms and add color depth. Oil paint may be safely applied over dried acrylic polymer underpainting.*

Tilting the working surface while the paint applications are wet can cause additional running and blending. Different degrees of paint thickness and viscosity require different dripping and pouring procedures and influence the appearance of the dropped paint.

Spattering techniques vary with the implements used in the process. A thinned paint mixture may be flicked or flung on the working surface with a firmly held loaded brush. It may also be applied by striking the handle or ferrule of the brush against the hand or some firm object to project the paint droplets in the direction of the working surface. Some atomizers and sprayers also produce spattering effects, and the nozzles of many sprayers can be adjusted so that they spatter efficiently while using a short burst technique of spraying.

Running differs from trailing or dripping in that the paint is applied to a vertical or tilted working surface and is caused to run by manipulating the working surface or by blowing air upon the thinned paint mixture from the mouth or a compressor, vacuum cleaner, or other machine capable of concentrating and forcefully directing the air so as to move the paint over the working surface.

Rolling

Paint may be applied with rollers to produce a variety of textures and appearances. Conventional house-painting rollers, both textural and plain, may be employed for backgrounds and large simple areas. The paint mixtures may be thinned with plain water or, if the mixture is to be a very thin one, water and medium.

Interesting textural and patterned effects may be achieved with block-printing rollers, or brayers. They should be coated or "loaded with paint" and rolled over a working surface strewn with flat-shaped objects, string, etc. The objects are removed afterwards.

With practice, small soft rubber rollers may be used to apply paint in a very controlled manner that will produce linear, blended, textural, and flat-area qualities. The technique involves rolling the brayer on its end for linear effects and squeezing or compressing the soft roller into various shapes with strong pressure while rolling for the blended, textural effects. Moistening the roller before using it makes applications easier.

Detail from a textural materials collage, utilizing such materials and objects as tissue and water-color paper, a washer and scraps of dried acrylic polymer torn from used paper palettes.

Acrylic Polymer in Collage-Making

A collage is a composition made primarily by gluing and pasting papers, fabrics, and miscellaneous textural materials to a working surface, frequently in combination with paint and glaze.

As a medium for creative expression, the collage has unlimited possibilities. Its many approaches are easily adaptable to various styles, and its techniques find practical use with nearly every category of art, including drawing, painting, sculpture, and printing.

Today's interest in found objects, lifted images, and textural materials has focused attention on collage-making as an independent art form. Acrylic polymer, because of its flexible, adhesive, and preservative qualities, is ideally suited for this.

As with all media having no sharp divisions in the categories, it sometimes may be difficult to distinguish between a painting, sculpture, construction, or a collage. This chapter deals with basic collage-making techniques and their concepts and contains suggested exercises.

Use of the Gloss, Matte, and Gel Mediums As Adhesives

The matte, gloss, and gel mediums, because of their strong adhesiveness, flexibility and nonstaining clarity, are ideal as adhesive and preservative agents for collages. Before artist's acrylic polymers were popular and easily available, collage-makers used the white polyvinyl home and shop glue. Its great disadvantage is brittleness. Traditional commercial var-

nishes, when used as collage adhesives and preservatives, also turn brittle and discolor very quickly. Because many of the textural and decorative materials used in collages are basically impermanent, their preservation is necessary if the collage is to be a permanent art form. Artist's acrylic polymer makes this possible.

The liquid matte and gloss mediums and the gel have their own special qualities and uses for collage making. Understanding these characteristics will enable you to make advantageous use of them.

The Liquid Mediums—
Matte and Gloss

The main difference between these two mediums is that the matte medium dries with a nongloss or matte finish, while the gloss medium dries with a gloss or shiny finish. Their adhesive qualities are about the same. Since these liquids flow, brush on, and penetrate absorbent materials easily, they are best suited for use as adhesives for thin, lighter materials, such as papers, thin fabric, string, and yarn. They also serve as excellent binders for small textural and decorative additives and as preservative and protective coatings.

The Gel Medium

The gel medium, because of its thicker viscosity, is ideally suited for affixing heavier materials, such as wood, cardboard, thicker fabrics, pieces of metal, glass, and stone.

Materials for the Working Surface

There are many types of collages, and numerous materials may be used for working surfaces and backings for them. Your selection will depend upon the size and kind of collage as well as upon the availability of materials. Collages with large, heavy objects and materials attached to them require strong, rigid support. Those using lighter, thinner materials require less support and may be treated like paintings. Small tissue-paper collages and others with flat surface applications of materials may be executed on paper and cardboard. Refer to the working-surface chart in Chapter 2 for additional help. Further suggestions are made about materials for your working surface in this chapter's suggested exercises.

The Lisbon Linen Vender by Jean Craig. Acrylic polymer on Masonite panel. This artist frequently uses her knowledge of collage making for incorporating textures into her paintings. In this picture the texture in the linen is achieved by adhering crumpled Japanese rice paper to the working surface with gloss medium and then painting over it when dry.

General Gluing and Pasting and Special Adhesive Techniques

Most materials are attached to the working surface in the same general way, but some require special preparation and gluing techniques. All gluing and pasting procedures may be loosely divided into the following two categories.

Gluing and Pasting Techniques

A good general rule is to liberally coat both the surfaces to be joined, using the appropriate adhesive, and then to press them together. This will take care of most situations and materials. Practical common sense and some experimentation are the best guides when you are unsure of the adhesive or procedure.

When attaching heavy objects that may slip or fall from the working surface while the adhesive is drying, it is best to keep your work horizontal. Certain objects may have to be temporarily held in place until the adhesive has set.

Special Adhesive Techniques

When thin papers such as those found in newspapers and magazines are attached to the working surface, wrinkles frequently develop during drying. This is because the moisture in the liquid medium causes the paper to expand while drying. By moistening these papers and allowing them to expand before gluing them

down, this problem may be solved. An excellent variation of this is to soak the papers for a few minutes in a diluted 50/50 mixture of liquid medium and water. A flat, shallow tray or bowl may be used for this. Coat the working-surface area where the paper is to be attached with this same medium-water mix and while it is wet, lift the soaking paper from the container and gently press it onto the working surface, brushing it softly to smooth out air bubbles: *NOTE: All mediums have a white or milky appearance when wet, but they will dry clear.*

Soaking before adhering will eliminate wrinkles from applications of

First Time Ever Offered *by Laura Ball, student at Warwick High School, Newport News, Virginia. Acrylic polymer collage on canvasboard panel. This study illustrates some of the possible combinations of collage types, utilizing various materials and gluing processes.*

tissue papers. *Much care should be exercised, since these materials disintegrate and dissolve very easily.* For this reason they must not be left in the medium-water mix for any extended length of time. Just quickly dip or moisten them and apply very gently to the working surface.

Yarns, strings, threads, and loosely woven fabrics may be soaked in undiluted medium and pressed into place on the working surface.

Sand, other small aggregates, and fine textural materials may be applied to a surface generously wet with undiluted medium.

Seeds, beads, pieces and bits of ceramics, plastic, glass, metal, and stone may be individually glued down with a glob of gel. If many pieces are going to be applied close together, they may be pressed into a thick coat of wet gel that has been applied to the working surface with a palette knife. Heavier nonabsorbent, shiny, and smooth-surfaced objects, with no roughness to grip the adhesive, may be attached permanently by gluing and completely surrounding them with a thin coat of gel medium.

Materials Needed for Collage-Making

1. Acrylic liquid mediums, gels, gesso, and the basic list of paints.
2. Basic list of brushes and palette and painting knives.
3. Several sheets each of white and assorted colored tissue paper.
4. Assorted scraps of different fabrics, both plain and with designs.
5. Assorted scraps of papers, such as foil, wallpaper, and other colored papers.
6. Colored strings, threads, and yarns.
7. Scraps of textural materials, such as rug samples, sandpaper, leather, etc.
8. Scraps, bits, and pieces of interesting metal, ceramics, glass, plastic, wood, etc.
9. Magazines, newspapers, and other printed matter.

Collage Types and Suggested Exercises

Collage-making has many approaches. Your personal tastes will find appropriate ways for expression through experience with the various processes and types. The nature of some of the materials might suggest both realistic and abstract use of them. One value of experimenting is that it offers the opportunity for various materials and techniques to suggest avenues of interpretation. Try all methods, techniques, and exercises, and while working, keep in mind that simplicity is a good objective, since the use of so many different materials and techniques could lead to confusion and clutter. Empty spaces, painted or left the color of the working surface, can be important to the total composition.

The products of these exercises may range in size from 9″ × 12″ to 18″ × 24″ or larger, depending upon your objectives. It is best to keep them small until you have experienced some of their many possibilities. Chipboard, Upson Board, mat board, canvas board or stretched canvas, Masonite and other hardboards make suitable working surfaces. Both sides of Upson Boards, cardboards, and mat boards should be coated with acrylic gesso, paint, or medium to prevent them from warping.

The Tissue-Paper Collage

This kind of collage is made by cutting or tearing various shapes from colored tissue paper and affixing or laminating them with liquid acrylic medium to a light-colored working surface in a flat or crumpled manner. Color is derived entirely from the color of the tissue. Layering several tissues of different colors one over the other will produce a variety of colors and tonal effects. The acrylic medium causes the tissue to become transparent or translucent when it dries, creating a glaze-like effect. Many artists prefer the textural effect of wrinkled tissue and strive for this quality by brushing liquid medium on the working surface and pressing dry tissue directly into it, sometimes crumpling and pressing before finally brushing medium over the top of it. Experimenting will help you to find your preference.

Unfortunately, most of the dyes used in colored tissue paper are not permanent and, when exposed to bright sunlight, fade very quickly. Several full days in bright sunlight will drastically change the colors; many of them will fade into gray. Under the normal light conditions of most interiors, the dyes will keep their color for several years but lose them rapidly after that. Many serious artists who employ this collage

Right: Show Time *by Vance Mitchell. Acrylic polymer collage on illustration board. This artist uses a very personal approach to collage making by combining textural materials, and found images with painting techniques.*

Below: City Impressions *by James Groody. Acrylic polymer collage on Masonite panel. Print of various size and color, cut from magazine pages form the basic structure of this picture, over which colored glazes are applied and lines drawn.*

method produce permanently colored tissue by tinting white tissue paper with thin acrylic washes before assembling the collage.

To achieve the best results in the beginning, strive for tonal contrast, using only a few colors until you become familiar with the process.

A final protective coat of gloss or matte medium should be brushed over the entire composition when completed.

The Found-Image Collage

The found-image collage combines various photographic and other pictorial images, as well as lettering and print from magazines, newspapers, and other printed matter. The materials are either cut or torn into different shapes and arranged in meaningful, sometimes surrealistic, compositions, many with unusual perspectives that result from combining images of contrasting size and type. Color is derived from the colors in the found images. Most often these images are affixed flat to the working surface. It is not unusual to use whole pages from magazines combined with significant words or printed phrases lifted from other sources. The completed composition is given a final protective coat of medium.

The Textural-Materials Collage

In this type of collage, the composition is made up of contrasting textural and patterned materials in various shapes and sizes arranged in an interesting manner and glued to the working surface. Real objects, such as buttons, souvenirs, and unusual mementoes, are often incorporated. The color in these compositions is derived from the materials, which are selected for their color as well as texture, sentimental value, etc. When the materials require preservation or surface unity, the completed collage is coated with one or several coats of medium.

Opposite: Abstraction *by Theresa Williams, student at Warwick High School, Newport News, Virginia. Acrylic polymer, tissue paper collage on paper.*

This found-image collage on a paper working surface created by a student at Warwick High School, Newport News, Virginia, is made up entirely of sections cut from magazines.

Erosion Fields *by Jack Fretwell. Acrylic polymer on corrugated cardboard. Using only the textural, patterned material of corrugated cardboard, Fretwell relies heavily on the play of light to accentuate forms in the finished product. After assembling and gluing the cut and torn sections and before adding the final colors, they are given several coats of acrylic polymer gesso for preservation and strength.*

All collage types are combined on a mat board working surface by a student at Warwick High School, Newport News, Virginia, to create these striking results.

Combining Collage with Paint and Glaze

The tissue-paper, the found-image, and the textural-materials collage are the three main types of collage. Most compositions modify or combine these, often incorporating applications of paint and glaze. The collages that you have done as examples of this may be used in the combination exercises, or you may choose to complete new ones.

When combining many materials and techniques, you may feature each element equally, or to avoid confusion in organizing these compositions, select one technique as the dominant one for the basic composition, using the other techniques for color, tonal, and textural accents.

Possible Collage Combinations

1. Colored Tissue with Paint and Glaze: Transparent colored glazes are brushed over areas of the composition, adding additional combina-

tions of tone and color to the pattern already established with colored tissue. The advantages of this combination are that it allows glazes to establish patterns in contrast to those made by the tissue, and it can help unify the composition by simple transparent color and tonal patterns.

2. Crumpled Tissue with Paint and Glaze: Crumpled tissue, usually white or of one color, saturated with acrylic medium mix, is pressed and formed into patterns and designs throughout the entire composition, then tinted and colored with either transparent glazes or paints or both.

3. Tissue with Found Images, Paint, and Glaze: Pictures, printed type, and found images of various kinds are combined with both crumpled and flat applications of tissue. Paint and glaze are used in abstract, broad tonal areas and also in descriptive and pictorial fashion. Usually the

composition progresses by gluing the found images to the working surface and then applying the tissue, paint, and glaze.

4. Textural Materials with Paint and Glaze: Paint and glaze are used primarily to add color and tone to the composition in a broad and abstract or in a pictorial, descriptive way. They may fill empty spaces on the working surface where no textural materials are used or be applied over and into them.

5. Paint and Glaze with Found Images and Textural Materials: Any number of combinations incorporating all of these elements is possible. Success will be more easily achieved if you select a theme or idea and use the techniques and materials so that each contributes its individual character towards carrying out the idea, letting a few factors dominate.

Simplicity *by Jean Craig. Acrylic polymer collage on Masonite panel. In this picture, an actual dress pattern has been applied to the painting surface using the liquid acrylic polymer medium as the adhesive.*

Collage *by Alice Hendricksons on stretched canvas. Real leaves and butterflies are combined with layers of tissue paper in this example of a collage utilizing natural objects. The leaves were tinted with acrylic polymer washes to prevent fading. The acrylic polymer mediums were used to adhere and seal the various layers of objects and sheets of tissue.*

*This nostalgic image was created on a
paper working surface by a Warwick High
School student in Newport News, Virginia,
through a combination of tissue, found-image,
paint and glaze.*

Related Collage Techniques

Other techniques similar to collage also emphasize pasting and gluing and thus merit inclusion in this chapter. The mosaic, the transferred image, and the decoupage are interesting collage variations worth experimenting with.

The Mosaic

The mosaic concept or process involves the creation of a picture, design, or composition by gluing or attaching small bits or fragments of materials to a backing, ground, or working surface. Usually this process is associated with large-scale architectural decoration, making use of small pieces of ceramic tile, glass, or stone cemented into place. In this chapter we will deal only with small scale-adaptations; in addition to those materials just named, mosaic pictures and decorative designs will be made from seeds, bits of plastic, small pieces of wood, cut or torn paper, fabric, or other materials used singly or in combination. Most often the color of these materials is the only source of color for the mosaic.

For those compositions made with tile, glass, stone, and like materials with some weight and density, the acrylic polymer gel medium may be used as the adhesive and the modeling paste as a grout or crack filler. An interesting effect may be achieved by filling the cracks in the mosaic with clear acrylic gel or colored, transparent glaze made with it.

The acrylic polymer paints may be employed to color papers, wood, seeds, and fabrics used in other mosaics. The liquid and gel mediums may serve as adhesives and protective and preservative coatings.

Mosaics made by pasting small pieces of cut or torn colored paper to a backing are easy and fun and look interesting when finished. The gloss or matte medium makes an ideal adhesive, and a coat of it over the entire finish helps make the work

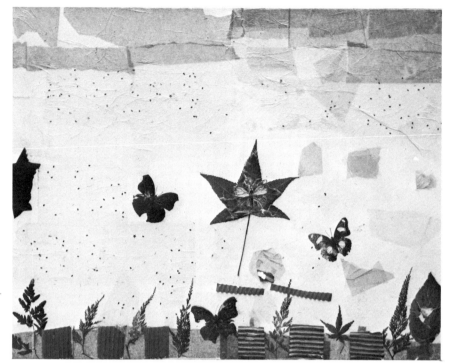

This natural collage was created by Luranah Woody, five-year-old daughter of artist and author Russell Woody, using acrylic polymer gel and liquid medium as the adhesive and as protective and preservative coatings.

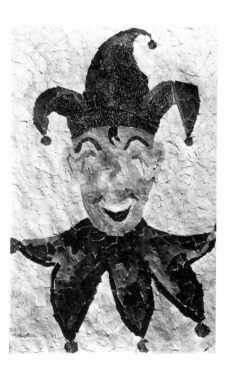

Jester by Michaelene Cox, student at Warwick High School, Newport News, Virginia. Torn paper mosaic collage. This collage was made of colored fragments torn from magazines and glued with acrylic polymer gel to a sheet of water-color paper. When completed, a coat of acrylic polymer gloss medium was applied to the surface for protection.

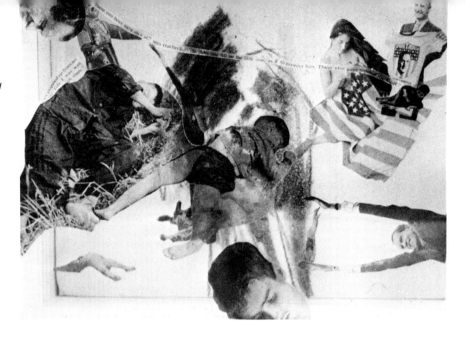

My Lie Box *(viewed from the front) by Russell Woody, is composed of transferred images adhered to both back and front of two transparent lucite panels set one in front of another into a box with a canvas back. The final effect is one of great depth with the floating images superimposed one over the other. Frequently Woody combines direct painting and glazing with the transferred images on the panels as well as on the canvas backing.*

durable and permanent. Colored construction paper is frequently used in this kind of mosaic, but unfortunately its color fades rapidly. A permanently colored paper may be made by coating sheets of paper with acrylic polymer paints in the selected colors and tearing or cutting them into the small mosaic pieces when dry. A block-printing roller, or brayer, is an effective tool for applying the paint.

The Transferred Image

This process could easily be classified by itself as a special technique. Because these images, once fabricated, must be attached or glued to some ground or surface, this technique has been included as a collage type.

The image is lifted or transferred from a picture or design reproduced in color, of the type printed in magazines and books. The front of the picture is coated with several layers of undiluted gloss medium. When dry, the whole picture is soaked in water for 5 to 10 minutes, or until the paper becomes soft. The back of the reproduction is then scrubbed with a brush, removing the softened paper and leaving the reproduction on the transparent skin of gloss medium. Since the inks used in reproduction printing are transparent, the result is a lifted or transferred transparent image, which may be glued with liquid medium or gel to a variety of surfaces and used in a number of ways.

The transferred image may be incorporated into paintings and collages, attached to three-dimensional forms as in sculpture, or affixed to clear plexiglass sheets, which when framed or boxed off and illuminated with a self-contained source of light are capable of producing powerful and dramatic visual effects.

Since the gloss medium is elastic, these transferred images may be distorted by stretching before adhering, but because of the natural tendency of the dried skin of medium to return to its original shape, it must be held in the desired position until the adhesive sets.

Decoupage

Decoupage is the craft or technique of cutting shapes, pictures, and designs from paper and gluing them in a decorative manner, often combined with paint, to various surfaces and objects, such as wooden jewelry, cigarette boxes, lamp shades, and other similar forms. Numerous coats of varnish are applied until the paper design appears to be laminated or imbedded into the object's surface. For a satin finish, it is rubbed down with pumice and then waxed. A common practice is to give these objects an antique finish by rubbing, glazing, or dry-brushing raw umber or other colors onto the surface before the final finishes are applied.

The acrylic gel, gloss, and matte mediums make ideal adhesives and varnish coatings for the decoupage processes. Use the appropriate gluing method and medium for the materials involved. The transferred image may also be incorporated into various aspects of this craft.

The rapid drying of acrylic polymer is an advantage in the decoupage technique, where many coats of paint and varnish are a necessity. When using traditional oil paints and varnishes, much time is wasted waiting for colors and coatings to dry before others can be applied.

Numerous books have been written about decoupage and there are many variations in the technique. It is not the intention of this book to explain the subject and its many techniques in depth, but only to introduce the basic concept and to show how acrylic polymer may be incorporated into it.

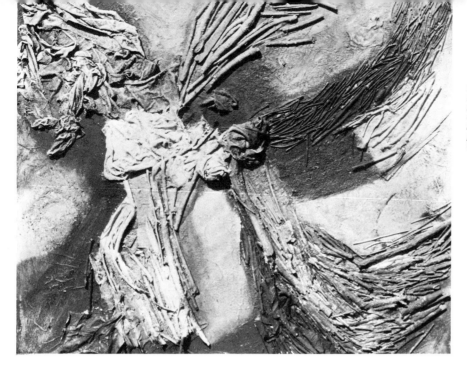

Macrocosm *by George Chavatel. Acrylic Polymer in combination with other media and materials on Masonite. In this powerful composition, artist Chavatel uses organic materials, cloth and other textural materials preserved in combinations of polyester, enamel and acrylic polymer.*

Questions Frequently Asked about Collages

1. *Is it true that coating colored tissue and other paper and materials with acrylic gloss or matte medium will prevent the colors from fading?*
No, these clear coatings will not prevent dyes and other colors that are not colorfast or permanent from fading. If the light can pass through these coatings, it will eventually bleach out impermanent colors.

2. *Sometimes during the process of soaking, expanding, and affixing colored reproductions from maga-* ***zines to the collage working surface, the inks rub off the paper surface. How can this be prevented?***
The reproductions are probably being soaked too long in the process of expanding. These papers have a fine coating of clay on them, over which the inks are printed. Exposure to moisture softens this clay and the inks rub away. Rub the front of the reproduction as little as possible (and then very gently) while you are gluing it or coating its surface with medium.

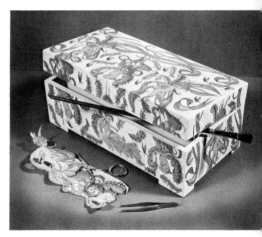

Decoupagé Box *by Mamie Provo. Decoupagé artist Provo uses acrylic polymer in collage techniques. The rapid drying of acrylic polymer saves time and adds permanency to the finished results.*

Coating, Preserving, and Protecting Your Finished Collages

Collages made with durable materials on strong backings may be treated like paintings, that is, coated with one or more layers of acrylic gloss or matte medium and framed without glass. Those made on working surfaces that are not durable and those fabricated with materials and objects that are fragile and easily damaged should be coated with medium to help preserve the materials. They may then be placed under glass or plexiglass to protect them from dust and dampness.

Untitled *by Thelma Akers. Acrylic polymer sculpture. This sculptured relief was constructed in several stages, using combinations of Styrofoam shapes, stretched skins of gel medium, and mirrors glued to an Upson Board backing with acrylic polymer gel medium. The general process is described in the adjoining illustration.*

This photo shows the early building stages of the completed sculpture, pictured in the adjoining illustration. Several coats of gel medium are brushed on a flat panel of Styrofoam and allowed to dry. Sculptress Akers then peels away these leather-like, translucent skins and stretches them across openings carved in Styrofoam forms in which mirrors have been embedded. Gel medium is used for the adhesive with pins and clamps, holding the skins in place until dry. Additional forms and layers are added with shaping being achieved by carving with a utility knife. Colored transparent glazes of paint, gel and gloss medium are added in the latter stages, creating in the finished sculpture a luminous quality of inner light resulting from the light reflecting mirrors.

Other Uses for Acrylic Polymer

While this book is concerned primarily with various aspects of acrylic polymer as related to painting, for the sake of informing the reader and encouraging him to experiment, brief mention will be made of some additional artistic uses of this versatile medium.

Sculpture

There are many ways in which acrylic polymer may be used in the sculptural processes from modeling, building, and constructing to texturing and painting the finished product. Most of its practical uses in the actual production of sculpture employ the usual simple tools, procedures, and techniques of modeling with paste or dough and the wrapping and wadding techniques associated with papier-mâché. Whatever the method, when working large it is generally more practical for the sake of expense as well as lightness to think in terms of building over armatures and supports.

Light and durable sculpture in literally any size may be made by wrapping or wadding sheets or newspaper, paper towels, or tissues, dipped into a mixture of 1 part gloss or matte medium and 3 parts water, over various forms determined by the size, shape, and available materials. They include wood, cardboard, wire, screening, wadded paper, balloons, etc. Texture and smaller details are easily achieved by using acrylic modeling paste applied with a knife or brush. When dry, this can be carved and sanded. Before finishing you may wish to add a coat or two of acrylic gesso, since it makes a good

These constructions were made from cardboard by Frank Trozzo, student at Virginia Wesleyan College, using acrylic polymer gel medium for the adhesive. Modeling paste was used to fill holes and cracks and for textured areas. Each construction was given several coats of acrylic polymer gesso and finished with a protective coat of matte medium.

base for any details or colors you might wish to add —using the acrylic polymer paints. A final coating of undiluted matte or gloss medium gives additional strength and protection.

An inexpensive and efficient sculpturing dough or modeling paste can be made by mixing shredded or chopped newspaper, tissues, or paper towels with water and acrylic polymer medium. Other additives such as sawdust, lint, sand, and similar materials may be included. Experiment with the amounts of each ingredient until a good working consistency is achieved. Most often better results occur when the largest portion of the mixture and its bulk consist of the shredded paper, medium, and water. The addition of acrylic polymer gel to the mixture produces a quality that allows it to be spread and applied easily with a putty or palette knife.

Right: Sixth to Ninth Hour, No. 15 *by Russell Woody. Sculptural projection from a flat black canvas, using acrylic polymer paint and modeling paste. The projection is made from a modeling paste, or "clay" consisting of black acrylic polymer paint, celite, celluclay and acrylic polymer gel medium mixed in various proportions to achieve workability and viscosity. Using the gel will keep the mixture from cracking as it dries. Drying time for the sculpture may be speeded up by placing it in an oven at 300 degrees F.*

Above: Abstraction *by Nancy Camden Witt. Shaped canvas stretched over a frame made from iron rods. For permanency, she gives the sculpture several coats of acrylic polymer gesso before painting it with the acrylic paints.*

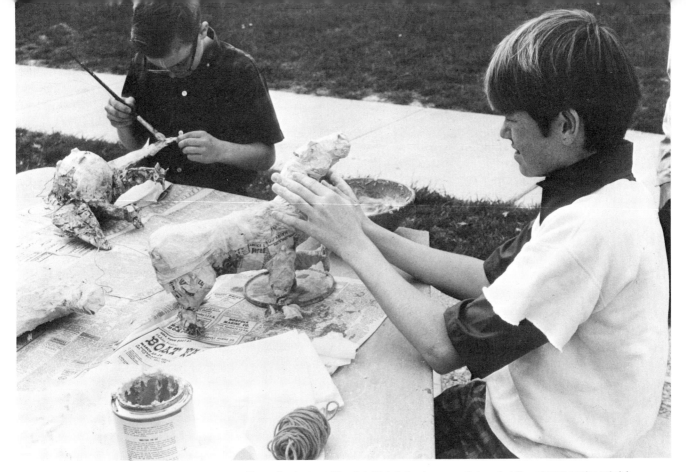

Above: Students at Warwick High School, Newport News, Virginia, form figures using papier-mâché principles made with paper towels and newspaper dipped in a mixture of acrylic polymer medium and water.

Below: Acrylic polymer papier-mâché sculpture may be coated with acrylic polymer modeling paste for a strong, smooth or textured finish.

Above: The Patriot *Acrylic polymer papier-mâché sculpture built around a wooden armature by a student at Warwick High School, Newport News, Virginia. Completed sculpture was painted with acrylic polymer paints and given a protective finish of gloss medium.*

Right: Study by Nancy Sweet, student at *Virginia Wesleyan College. Acrylic polymer papier-mâché sculpture built around a crumpled paper form.*

Quest *by James Kirby. Silk-screen print using acrylic polymer paint as silk-screen ink on paper. While doing this multi-screen print, artist Kirby found that he could produce transparent colored glaze effects by mixing gloss medium with the paints.*

Printing

Acrylic polymer has valuable uses in the making of prints. For example, smoothly coating the surface of a block or panel of Upson Board, firm cardboard, Masonite, or wood with modeling paste and allowing it to dry makes an ideal surface in which to cut and carve a design for block printing. Incorrect cuts are easily corrected with the modeling paste. Designs can also be built up, and prints and rubbings made from them.

Acrylic polymer paints may be used as a durable, waterproof, and permanent ink in the silk-screen process of printing.

Many artists use the liquid mediums and gels to make relief and textural collages on a firm, backed working surface. After being protected with coats of gesso and/or medium, they are inked and printed using an etching-type press. This general process is called collagraphy. Relief prints are possible by printing the collage without inking.

Nude *by Shirley Usinger. A print using two blocks, employing the extruded line technique, printed on rice paper. The first block used in this unique print was a wooden one with a raised grain. Printed over that was the second block on which the figure was drawn in relief, using the medium of modeling paste in the extruded line technique. Oil-base block printing ink was used for this print.*

Spring Hat *by author. Silk-screen print using acrylic polymer paint as the printing ink, printed on Upson Board primed with acrylic polymer gesso. When finished, this multi-screen print was coated with matte medium and framed without glass.*

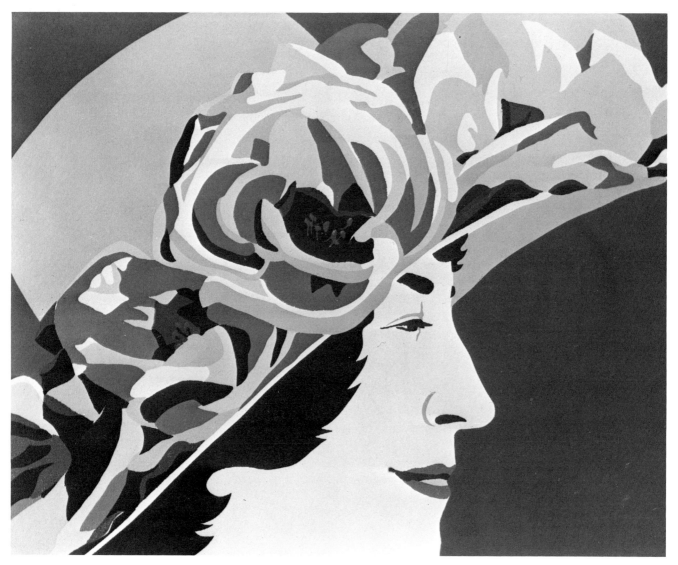

Untitled *by James Kirby. Silk-screen print where acrylic polymer paint was used as silk-screen ink on paper.*

Kineticism *collagraphy print by George Chavatel. Chavatel created the plate from which this print was made by coating a Masonite panel with acrylic polymer medium. Before the medium dried he placed pieces of paper, cloth, gauze and other textural materials onto the wet surface. The medium acted as an adhesive. When this was dry, additional coats of liquid medium were applied to seal the plate. The finished collage or plate was inked, placed in an etching plate under strong pressure and printed. Numerous variations related to this process are possible.*

Mural Painting

Acrylic polymer paints, liquid mediums, gel, and gesso may be used for executing murals and mural-type paintings, whose durability and water- and weather-resistant qualities make them excellent for outside as well as inside use. The same painting procedures may be used that are described in Chapter 2. Care must be taken to make sure that the plaster, masonry, wood, canvas or whatever working surface is used, is clean and suitable for acrylic paints. Acrylic gesso makes a good surface for receiving the paints. When finished, several coats of gloss or matte medium should be applied to the mural for protection.

Crafts

Acrylic polymer has numerous uses in crafts. The liquid and gel mediums are excellent adhesives for the craftsman and useful for the hobbyist in the home shop. The modeling paste can be used for making figurines or jewelry and for decorative relief work or frames. It makes a good general-purpose hole and crack filler that can be made any color with polymer paints.

Woodcarvers and modelers widely use the gel medium as a glue, the paints for decorations, and the matte and gloss medium as clear protective finishes.

Articles traditionally made from papier-mâché, such as trays, other containers, figurines, and toys, become permanent and more durable when made using the acrylic polymer sculptural processes described earlier in this chapter.

The paints are suitable for use on almost any surface or material used by the craftsman, including leather, fabric, wood, masonry, ceramics, cardboard, and paper. They make excellent textile paint and may even be used as a fabric dye for such techniques as tie-and-dye or batik.

Above: Compote by a Menchville High School student, Newport News, Virginia. This striking piece was made from acrylic polymer papier-mâché, built around inflated balloons and decorated in a linear relief of string saturated in acrylic polymer liquid medium. Brightly colored acrylic polymer paints and several protective coats of gloss medium were used as a finish.

Right: This bisque fired ceramic pot, made by a Menchville High School, Newport News, Virginia student was given a permanent design of acrylic polymer paint and finished with a coat of acrylic polymer gloss medium.

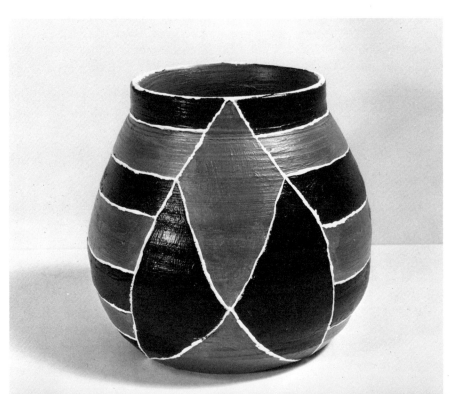

Matting, Framing, and Preparing Work for Exhibition

There are numerous books that more than adequately cover the subjects mentioned above. With a utility knife and a little practice, one can soon learn to cut and prepare his own mats. The same is true for framing. With a saw, a simple miter box, and common sense plus a little inventiveness, one can make inexpensive, attractive frames using common unfinished moldings found in most lumber yards and building-supply houses. Simply by asking other artists and by observing, one may learn much about exhibiting and preparing his work for exhibits. The following brief remarks pertaining to these topics are included for information's sake and are intended to give the beginner or the un-initiated some general ideas about these matters.

Matting

A mat is a flat border of cardboard or matboard surrounding a picture. It is a single piece with a hole cut in it slightly smaller than the picture. The picture is centered in the opening and attached from behind. The purpose of a mat is to create a sheltered environment so that the picture in it can be seen to advantage. The kinds of pictures that are usually matted are etchings, drawings, line and washes, water colors, and some collages. After matting they are placed in a simple frame under glass. Many artists whose pictures are protected with acrylic polymer medium do not use glass. If you frame matted pictures without it, a good procedure is

to give the mat a coat of acrylic polymer gesso, paint, or medium to protect it.

A general rule to follow for deciding upon the width of the mat around the picture is to make it from 2 1/2" to 4", depending upon the picture. Sometimes a very small picture requires a large mat and to keep it from looking lost. Most artists use the same width on the sides as on top and bottom. Others leave a slightly wider space at the bottom.

There are several mat-cutting devices available; however, most artists prefer using an inexpensive utility knife. To avoid mistakes, be sure to measure carefully before cutting.

Matboard comes in many colors and can be covered with various fabrics. It can also be painted. White and gray are the most widely used colors because most pictures can be seen to advantage in them. Brightly colored mats tend to detract from the picture.

Mats are easy to cut with a utility knife using a straight edge as a guide. Check the measurements carefully and always put a protective pad of cardboard or paper under the mat board where the cut is to be made to keep the knife blade from cutting through the mat and scratching the work table.

Framing

It has often been said that a frame can make or break a picture. In many ways this statement is true. A picture that is poorly framed does not look its best, to say the least. Frames are expensive, and sometimes a picture that has a neat, simple homemade stripping around it looks far better than one with a costly, ornate molding that is not appropriate.

The selection of frame styles and molding types has a lot to do with personal taste and choice as well as current vogue and popularity. There are, however, a few basic, logical guidelines that can help in this type of decision-making.

1. Use narrow moldings for prints, drawings, and water-color type works that are matted. The width of the mat eliminates the need for a wide frame.

2. Wider, heavier, more ornate moldings can be used more successfully on larger, bolder, less delicate works, such as paintings with heavier paint applications and strong colors.

3. When in doubt, remember that a simple light, dark, or metallic stripping-type of frame will set off any kind of picture.

4. When in doubt about color and finish selection, remember that most pictures look their best in light or neutral colors and tones.

5. If undecided about whether to select a simple or an ornate frame, remember that nearly every picture looks good in a simple one.

Many artists make their own attractive frames using simple carpenter's tools and unfinished moldings available at most any home and building supply outlet or lumberyard. They may be decorated with relief designs and patterns made from acrylic polymer modeling paste and painted with the acrylic polymer artist's colors.

Above: For paintings on stretched canvas, lattice stripping, available at lumber supply companies, may be cut without a miter box and nailed directly to the wooden stretchers to create a simple but effective frame. It may be allowed to project beyond the surface of the painting as in the illustration or kept flush with it. Cracks may be filled with acrylic modeling paste and sanded before painting.

Lattice stripping is often available with either a grooved or smooth surface.

Below: Paintings done on panels which are not warped are easily framed with stripping, providing a simple frame is first made and glued securely to the back of the painting, as shown in the illustration. When dry, the stripping is nailed to this.

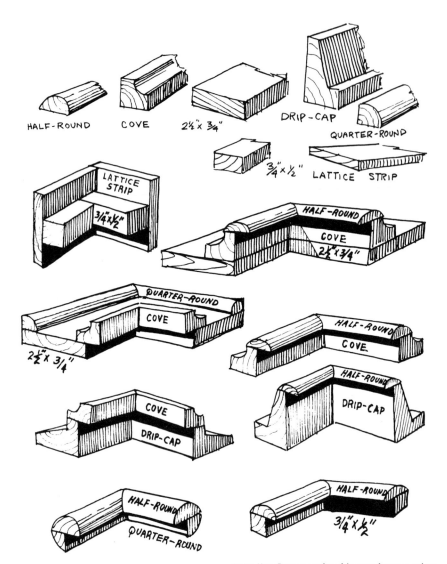

HALF-ROUND COVE 2½" x ¾" DRIP-CAP QUARTER-ROUND

LATTICE STRIP ¾" x ½" ¾" x ½" LATTICE STRIP

LATTICE STRIP ¾" x ½" HALF-ROUND COVE 2½" x ¾"

QUARTER-ROUND COVE 2½" x ¾" HALF-ROUND COVE

COVE DRIP-CAP HALF-ROUND DRIP-CAP

HALF-ROUND QUARTER-ROUND HALF-ROUND ¾" x ½"

Artist Ken Bowen makes his own frames using common unfinished lumber and moldings available at most lumberyards. These drawings by him illustrate molding types, and show corner samples of various combinations possible for making frames. Acrylic polymer paints may be used for finishing them.

Preparing Work for Exhibition

When beginning to exhibit their acrylic polymer paintings for the first time, many individuals are confused when they find that numerous shows have classifications for water color, graphics, oil, mixed media, and other traditional categories, but often nothing for acrylic polymer. Fortunately, because of the growing popularity of this medium, this situation is beginning to change.

There are a few general, logical guidelines that one may adhere to when uncertain about how to classify paintings done in acrylic polymer.

1. If the painting has been executed on a paper or paper-type working surface and the paints have been applied as a water color with thin washes in a watery way, it may be classified as a water color.

2. Paintings on any working surface where the paint, whether thick or thin or applied with either brush or knife, has been applied in a non-water-color way, would be considered oil paintings.

3. Works in line and paint combinations could fall into several categories. If the line totally dominates the picture, it could be classified as a drawing, or "graphics." If it was done in line and wash and the wash totally dominates, it could go into the water-color category. If thick, heavy paint applications are most prominent, it could fit into the oil classification.

When preparing paintings for exhibition, all water colors and line and wash types should be matted and framed. If not framed, they should be covered with clear plastic or acetate and backed with firm cardboard. Larger, heavier oil type paintings should be framed. Many artists make effective use of simple stripping. Others simply put tape around the edges when framing or stripping is not available.

Further information concerning finishing, matting, and framing is provided at the end of Chapters 1 and 2.